SECRET WORTHING

James Henry & Colin Walton

AMBERLEY

First published 2016

Amberley Publishing
The Hill, Stroud, Gloucestershire, GL5 4EP
www.amberley-books.com

ISBN 978 1 4456 5140 8 (print)
ISBN 978 1 4456 5141 5 (ebook)

British Library Cataloguing in Publication Data.
A catalogue record for this book is available from the
British Library.

Typesetting by Amberley Publishing.
Printed in Great Britain.

Introduction

Every village, town and city has its secrets or little-known oddities and Worthing is no exception. The town is a popular south coast seaside resort, mixing Victorian, Edwardian and Georgian architecture with a dash of art deco and a pinch of medieval design. Its secrets are hidden away, or so you might think. Sometimes the best place to hide is in plain sight.

James Henry and Colin Walton are both established residents with a hankering for discovery, seeking out explanations for oddities and curios of what once was and what still is. We have uncovered answers to many age-old questions and some that have yet to be asked. Rest assured, however, that we won't bore you with too many facts and figures, but instead enthral you with points of genuine interest. These pages are an eclectic mix, a snapshot of times past, and are not just unique to Worthing; history is everywhere, all you need to do is look that little bit closer.

The house in the image? It belongs to the local water authority and is one of their pump houses. Rather than constructing an ugly industrial installation, it was decided to mellow its appearance by tastefully blending it into the environment.

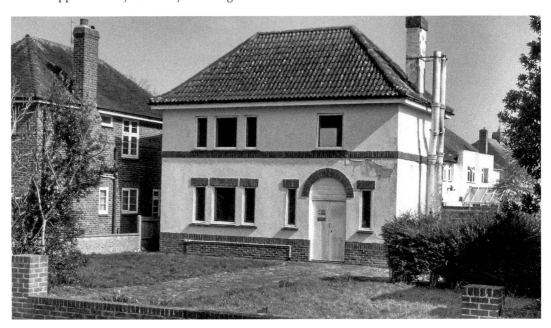

A house with no curtains, lights or letterbox.

A Brief History of Worthing

Today, Worthing is one of the largest towns in Sussex, a fact that belies its humble beginnings as a small Saxon settlement, possibly dating as far back as the fifth century AD. During this period, the area was slowly colonised by Germanic tribes.

Said to be the traditional burial ground of Saxon kings, neighbouring Highdown Hill has yielded grave goods dating back to around AD 450. Certainly, evidence exists of Stone, Bronze and Iron Age settlements, along with Roman occupation in the area, but little is known about Worthing as a permanent settlement until its mention in the Domesday Book, which was compiled in 1086. Here, the manor of Worthing was noted as consisting of two hamlets: Mordinges and Ordinges.

Passing through Norman hands, by the thirteenth century the town had been variously known as Wurdding and then Wortinge, but throughout all this it remained a small fishing and agricultural settlement.

Worthing, at this time, was part of the larger neighbouring parish of Broadwater and remained that way for many centuries. Still a small hamlet, the seaside resort we see today did

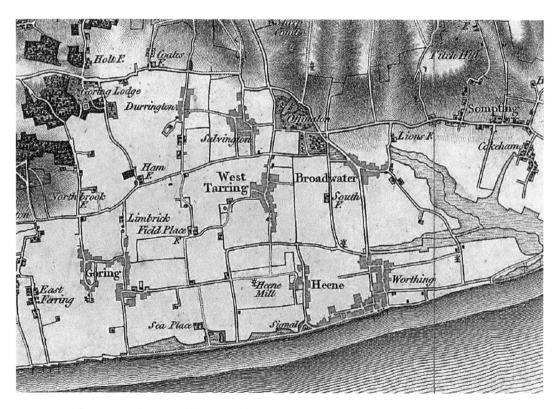

A map from 1778 showing villages and hamlets.

not begin to develop independently until the early nineteenth century. The map shown here, published in 1778 by Yeakel and Gardner, shows how the area looked prior to its expansion.

A visit in 1798 by George III's youngest daughter, Princess Amelia, brought the hamlet to the attention of the wider gentrified public, who began travelling to the town in the wake of the royal visit. This, in turn, spurred the development of housing and lodging accommodation, leading to Worthing receiving town status in 1803.

As visitors increased, so did the population; with the railway arriving in 1845 the town grew rapidly, absorbing nearby hamlets and villages, and was on the way to becoming a borough in 1890.

This book is not intended as an illustrated guide, but instead seeks to encourage local readers to discover aspects of the town's past that, through the years of building and redevelopment, remain today – little known oddities, often hidden in plain sight. Hopefully too, non-Worthingites will begin to view their own home towns through more enquiring eyes. Welcome to secret Worthing: *Ex terra copiam e mari salutem* – 'From the land plenty and from the sea health.'

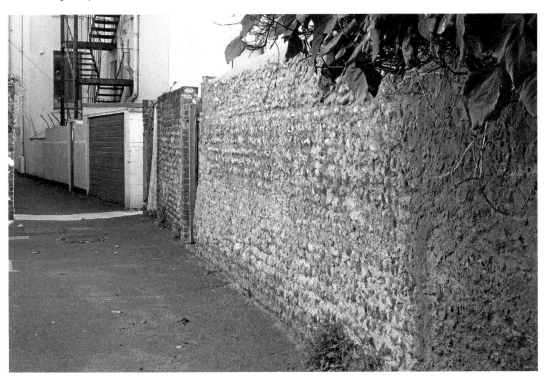

The ancient flint wall that used to mark the boundary between the villages of Heene and Worthing. Heene is now completely absorbed in the borough.

The King That Never Was

The image here shows a very rare example of an Edward VIII pillar box, of which only 161 were ever made. This example rests on the corner of Trent Road and Robson Road in Goring.

The scarcity of these boxes is due to the very short reign of Edward VIII, who was only king from 20 January to 11 December 1936. Edward, king but not yet crowned, expressed a desire to marry Wallis Simpson, a twice-divorced American. Under the British constitution, and with Edward as the prospective head of the Church of England, a marriage of this kind could not be permitted. For the sake of love, Edward made the decision to abdicate. His brother, now to become George VI by default, bestowed on Edward the title Duke of Windsor, allowing him to still be addressed as His Royal Highness. Simpson eventually became the Duchess of Windsor but was denied the address of Her Royal Highness.

Because of the previously assumed inevitability of Edward becoming king, new coins were produced, celebration china manufactured, tea towels printed and stamps designed in advance of the pending coronation. Many examples can still be found celebrating the event that never happened. Due to the large number of souvenirs and trinkets prepared beforehand, they are today generally novelty items of little or no value. The same can't be said for the postbox, silently doing its duty as if nothing had happened. Interestingly, because of the above events, 1936 would be the year we had three kings.

A rare Edward VIII postbox.

Another Red Box

A phone box to most, but to experts this is the much desirable K8, the last of the iconic red GPO telephone kiosks. This off-the-street example is under private ownership in Park Road. Consisting of just seven principle components, the four main sides were interchangeable, allowing the door to be positioned on any side with the whole thing held together by just eight bolts. Although mostly made of cast iron like its predecessors, the door was aluminium, making it easier to open. It also retained a large gap at the bottom to prevent it from getting jammed if a stone caught under the edge. Installed from 1968, hence the attire of the resident shop dummy in the image, 11,000 were produced. They were never intended to replace the familiar classic telephone boxes but were reserved for new installations. To date, only fifty-four have been identified as still in use.

The last of the red telephone boxes.

Mary Had a Little Lamb ... Or Did She?

Mary Hughes lays peacefully at rest in Broadwater Cemetery, she was ninety-one and the heroine behind the famous nursery rhyme 'Mary Had A Little Lamb' – or was she?

Mary was born in Llangollen, North Wales on 18 May 1842. Her father, John Thomas, was a sheep farmer in the valley. Attending Brook Street School, one day eight-year-old Mary had been followed there by one of the lambs that she had helped hand-rear on the farm. This, understandably, caused some disruption and, the teacher Mrs Coward, made Mary remove the creature and secure it to a nearby gate.

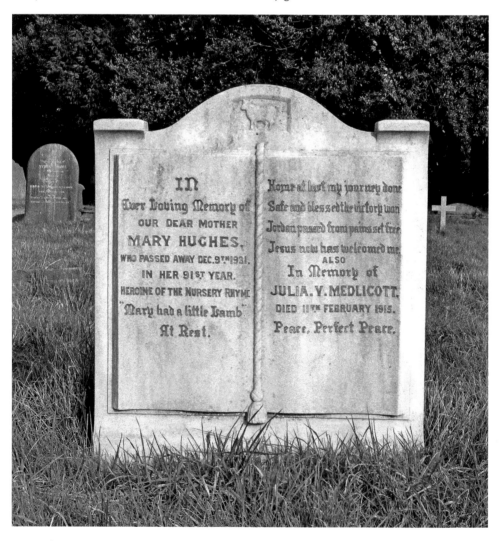

Mary's gravestone in Broadwater Cemetery.

The story goes: three maiden sisters by the name of Buel were staying at the farm at the time and one, being so struck by Mary's adventure, wrote the famous nursery rhyme based on the event. Mary's death at No. 11 Ethelred Road, West Tarring, was recorded in the *Worthing Gazette* on 12 December 1931, where the story of her fame was reiterated. It included the following quote from Mary: 'One day, when I was eight, Billy the eldest of the pets, followed me to the village school. He frolicked and scampered over the forms and gave us no peace, and the schoolmistress turned him out.' Mary also confirmed that the three Buel sisters, from London, had stayed at the farm at the time.

There have been many claims as to the origin and author of this children's favourite over the ensuing decades and there is no doubt that the story of a lamb following a child to school is a universal one. Where it falls down is the date. It was written and published in 1830, a full twelve years before Mary was born and twenty years before the claimed event happened.

Sarah Josepha Buell was born in October 1788 in Newport, New Hampshire (USA). She grew up to be a school teacher and later married David Hale. Sarah published her first book, a collection of poems entitled *The Genius of Oblivion* in 1823, and later a novel called *Northwood: Or Life North and South.* This latter work was published in London under the title *A New England Tale.* On 24 May 1830, she published *Poems for Our Children* which included 'Mary Had A Little Lamb', then titled 'Mary's Lamb'. Sarah had based her poem on the same incident of lamb-following, this time inspired by Mary Sawyer of Sterling, Massachusetts. Lowell Mason, a well known hymn composer, set it to music the same year. The rhyme also found fame as being the first thing Thomas Edison recorded on his newly invented phonograph, making it the first instance of recorded verse.

It is easy to see how Mary Hughes, or as we suspect, Mary's mother, came to believe that her daughter was the child heroine of the verse. Sarah published under the name Sarah Josepha Buell Hale and, due to the similarity of the three sisters, Buel and Buell became blended as one. Sarah had no sisters and only one brother. We believe it was purely accidental that Mary Hughes related the story to herself.

Birds of a Feather

Within Beach House Park stands an unusual memorial, one that commemorates Worthing's 'warrior birds'. These war pigeons, as they are generally known, were used to carry messages and explosives during the Second World War. Actress Nancy Price and members of the People's Theatre in London commissioned the memorial, while the design and build was left to the local sculptor Leslie Sharp.

Although the contribution of these pigeons throughout the war is widely recognised, this is thought to be the only memorial of its kind in the country.

Leslie Sharp began work on the structure in 1949, with the unveiling by the Duke and Duchess of Hamilton taking place on 27 July 1951. The memorial is maintained by the

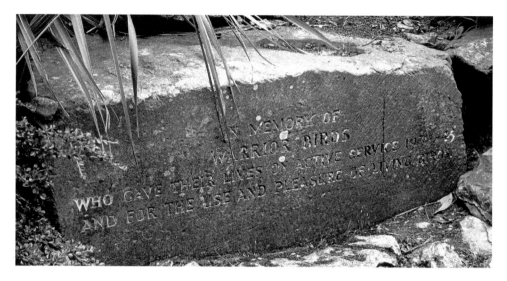

One of two carved stone memorials to the war birds.

borough council and has undergone changes over the years – it originally consisted of a circular mound with streams and pools of water. Two carved and inscribed boulders quarried in the Forest of Dean remain but two stone pigeon sculptures have long since disappeared, apparently stolen.

The inscription on the first boulder reads, 'In memory of warrior birds who gave their lives on active service 1939–45 and for the use and pleasure of living birds.' The second contains a quote from the Old Testament 'Book of Ecclesiastes' (Ecc 10:20) along with the words, 'A bird of the air shall carry the voice and that which hath wings shall tell the matter. This memorial is presented by Nancy Price and members of the People's Theatre, London'.

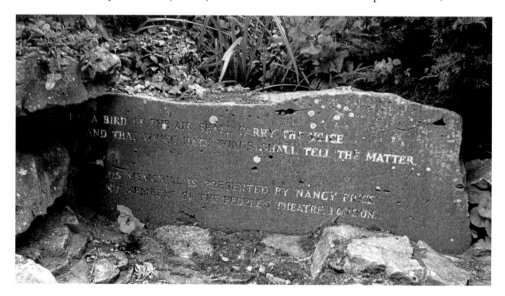

The second stone, presented by Nancy Price.

The Swandean Spitfire

Imagine the thrill as a school boy, out with dad in the family car, spotting a real life Second World War Spitfire on the forecourt of a petrol station, the thrill even greater when it was occasionally fired up.

Swandean Garage was situated on the A27, a busy main road at the top of Durrington Hill on the northern boarders of Worthing. The property was owned by Michael Wilcock, an engineering eccentric with a passion for mechanics and a taste for speed. It would have come as no surprise to anyone who knew him that when the opportunity arose to buy a Spitfire he did so. No doubt he saw this as a unique way to advertise his business with the added opportunity of tinkering with a Rolls-Royce engine – and all for the scrap value of £120. Allegedly, he had the choice of twenty aircraft on the day and Michael, being Michael, picked the blue one!

It is unlikely that he would have known its history at the time. Spitfire LF. Mk XVIe, Serial Number SL721, was the personal transport of Air Chief Marshal Sir James Robb, whose initials, JMR, adorned the outside. While some may aspire to a company car, Sir James had a company aircraft. This also explained its distinctive blue colour scheme.

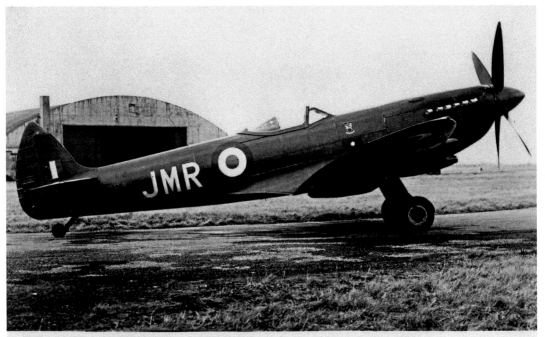

SPITFIRE FIGHTER of the 1939-1945 War
Preserved at Swandean Garage, Arundel Road, Worthing.

The Spitfire purchased by Michael Wilcock.

On Sir James' last day in the service, he flew his Spitfire to RAF Little Rissington in Gloucestershire, home to the Central Flying School. Here it was destined to become a working exhibit taking part in displays and special events. The aircraft was well suited to this form of work as it had previously been adapted, having its armaments removed along with its armour plate. The end result was a Spitfire with an enviable turn of speed.

Sadly, in 1955, the Air Ministry issued instructions for it to be flown to RAF Lyneham in Wiltshire where, in spite of many objections, it was to be scrapped. This was where Michael Wilcock found it.

The aircraft was to remain on his garage forecourt for several years and, on the anniversary of the Battle of Britain, the engine would burst into life in honour of those who gave theirs, a stirring sound to many for whom the war was still a recent memory.

In 1958, the RAF asked if he would lend the Spitfire for display at the Battle of Britain Day on Thorney Island. Here, it was overhauled and returned to flying condition. It was later that Wilcock found himself with a problem. The garage was doing well enough to allow him to expand and the Spitfire, when returned, would be in the way of future development. Lord Montague stepped in, offering space at the new Beaulieu Motor Museum, an ideal and timely solution to the problem. Although the aircraft was on loan, Wilcock did eventually accept an offer from M. D. Thackery to exchange the Spitfire for a vintage Bentley once owned by Wilcock's father, a deal which would have been hard to refuse. The aircraft remained at Beaulieu before again being sold on, this time to the Marquis of Headfort. In an odd turn of events, Thackery bought the aircraft back for considerably more than he sold it for. Of course, there was an ulterior motive – America.

In December 1965, SL721 ended up in Elstree, England, where it was dismantled, packed and sent off to Atlanta, Georgia. The Spitfire took to the skies again in May 1967. In spite of its previous distinguished owner, the aircraft was repainted in the more familiar camouflage livery.

In 1973, its wheels were once more back on British grass. Avid collector Doug Arnold had always desired SL721 and eventually purchased it. It was shipped from Baltimore back to the UK and reassembled in Leavesden, Hertfordshire. Here it donned the unsurprising identification designation of D-A. We're not sure why, but Doug Arnold was to later sell the aircraft, rather ironically, back to America. Its last known address as of 2013 was Ontario, Canada, where it forms part of the Vintage Wings of Canada display team. We have concluded that this aircraft may have travelled more miles by sea than it has ever flown!

Are You Ready to Rumble?

As we've previously discovered, Michael Wilcock was a lover of powerful engines. It may have been with some personal regret that he never had the opportunity to experience the thrill and strength of his own Spitfire aircraft, but that wasn't going to stop him trying.

Wilcock purchased a Rolls-Royce Merlin XXV, a twelve-cylinder, twenty-one litre Spitfire engine, for little more than scrap value. His intention was to mount it in a car. Naturally, there was nothing on the market that could support the strength and weight of such a powerful engine; weak frames would simply twist and distort with the torque of 1,600 horsepower, so he built his own. The chassis was constructed from two Daimler Dingo scout cars, known as light tanks (possessing wheels rather than tracks), welded together. This combination resulted in a four-wheel drive vehicle measuring 13 feet 9 inches and, when complete, consumed an extraordinary 3 gallons of fuel per mile.

Wilcock recalls, in a letter to *Motorsport Magazine* in 1953, that the carburation and supercharging adjustments of the engine remained unaltered with the manufacturer's original seals still intact. He also mentions that he intended to replace the Spitfire radiator with a smaller one as, at present, the engine ran too cool. When it was tested on Madeira Drive on Brighton seafront in that year, a place where motor sport trials are still held to this day, Michael is quoted elsewhere as saying:

Below 100 miles per hour, wheel spin was possible on all four wheels, which is dangerous on courses like Brighton with a cambered road surface. Top speed in first gear was around forty-five miles per hour; second, eighty miles per hour; third gear 150 miles per hour, plus. I have no idea how fast it would go in fourth.

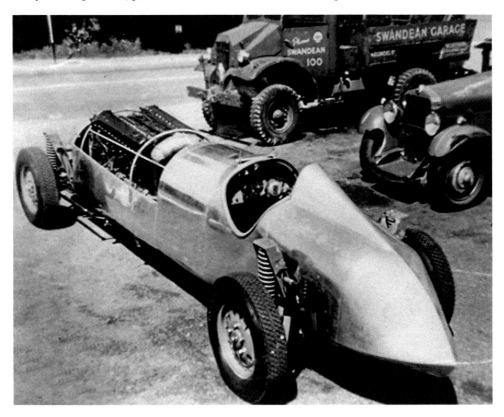

Wilcock's garage forecourt with the Swandean Special.

Wilcock ended his letter to the magazine with a cautionary note for other builders of racing car specials. Because of the publicity surrounding his vehicle, now known as *The Swandean Spitfire Special*, it had drawn the interest of Customs and Excise with the suggestion he may be liable for purchase tax. He said that if this proved to be so, he would be forced to break up the vehicle. Whatever the final outcome, Michael sold the car in 1956 when he retired to James Duffy of St Louis, Missouri. After that, it had several American owners and, for a period, fell into a state of neglect. It was eventually purchased by Stafford Lambert, owner of an engineering company and an avid collector of cars, planes and boats. The car has since been restored to full working order and has become a bit of an attraction at American sporting events. We understand it isn't used for racing anymore, which is probably a good thing.

DID YOU KNOW ?

Following the end of the First World War, a tank was awarded to the town as a mark of thanks for the contribution made by the borough during the war years. The presentation ceremony was carried out in front of the old town hall in South Street. The ultimate fate of the tank, a Mark V, is unknown. One rumour would have us believe that it is buried somewhere in the vicinity of Broadwater Bridge. Who knows, perhaps when the Teville Gate area is finally developed, it may be discovered.

Making a Song and Dance Out of it

North of Broadwater Green, just across the road on the west side, stands an ancient tree known locally as the Midsummer Oak or Skeleton Tree.

Legend has it that on midsummer eve, skeletons rise from beneath and dance around it until dawn. This is not unique to Worthing; folklore surrounding similar trees harks back to origins in our pagan past when midsummer, rather than Halloween, was regarded as the most auspicious time to commune with the spirit world.

As far as we are aware, the tree has never been scientifically dated, but it certainly stood there as a mature tree in the early 1800s and is clearly far older. A local woman by the name of Charlotte Latham recalls in her collection of Sussex folk customs from 1868,

There stood, and still may stand, upon the downs, close to Broadwater, an old oak-tree, that I used, in days gone by, to gaze at with an uncomfortable and suspicious look from having heard that always on Midsummer Eve, just at midnight, a number of skeletons started up from its roots, and, joining hands, danced round it till cock-crow, and then as suddenly sank down again. My informant knew several persons who had

actually seen this dance of death, but one young man in particular was named to me who, having been detained at Finden [*sic*] by business till very late, and forgetting that it was Midsummer Eve, had been frightened out of his very senses by seeing the dead men capering to the rattling of their own bones.

Detailed examination of the tree in 2006 revealed that it was suffering from brown rot; its destiny was sealed as removal was strongly recommended. A local campaign saved it, allowing future generations to dance with the skeletons each June. Local Worthing historian Chris Hare reported in *The Argus* newspaper in 2011 that since 2006, without any prompting, up to thirty people would turn up at midnight on midsummer eve to continue celebrating the local legend.

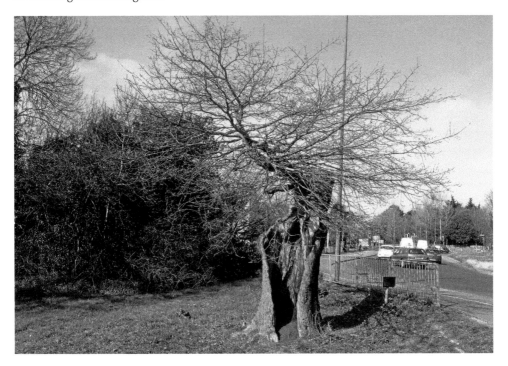

The Midsummer's tree, Grove Lodge roundabout.

Grave Concerns

A graveyard probably doesn't feature highly on your list of places to visit. This is certainly what passed through our minds when we discovered they had open days! Contrary to our initial expectation, no graves were actually exposed. This event is one of many annual guided tours given for free by the Friends of Worthing and Broadwater Cemetery.

Rather than the expected solemn procession among the headstones, we were given an entertaining, often amusing insight to the people whose stories would otherwise be forgotten. The graveyard itself was opened in 1863 and is home to 24,888 souls, and yes, in the early days graves were reused, resulting in unrelated individuals being stacked one upon another. In order to give you a taste of what to expect, we shall look at one example: Frank Foster Talbot Todd, who managed to run himself over with a steamroller.

Frank was born in Maidstone, Kent in 1870. By the age of thirty-two he had moved to Sussex Road in Worthing and began working for the local corporation as a steam engine driver. On Thursday 7 July 1910, his wife was informed that he had met with a terrible accident. Frank, with the assistance of two others, had been in Forest Road trying to replace a side wheel on his steam roller. The wheel, which weighed some 30 hundredweight (equivalent to 1.5 tons), slipped off its axle and fell directly on to Frank, crushing him instantly. An inquest heard that Frank had been a reliable employee experienced in the procedure of wheel replacement. A verdict of accidental death was recorded. The town finance committee decided that under the circumstances, his wife would carry on receiving his wages until suitable compensation was arranged. Frank's grave can still be seen today. A stone cross marks the plot with a carved steam engine wheel in the centre as a reminder of his tragic death.

We are grateful for the help and assistance of the Friends of Worthing and Broadwater Cemetery who organise these free tours, which are often themed to an area of interest, including: unusual deaths, entertainment and arts, old worthing families, publicans & hoteliers – to name but a few.

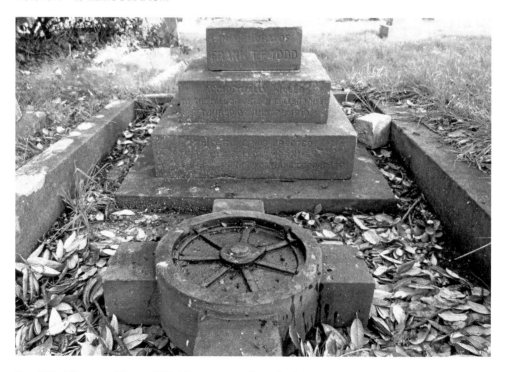

Frank Todd's grave. He was killed by a steamroller wheel.

An Inspector Calls

Few people today would know the name Crippen, but those of us of a certain age will be familiar with this infamous murderer. Even fewer would be aware of a retired Worthing resident named Walter Dew – the man who caught him.

Dew joined the police force in 1882 at the age of nineteen. In 1887, he became a detective constable in the Criminal Investigation Department, based in Whitechapel, London. He claimed to have had some involvement in the notorious Jack the Ripper case which was prominent at the time. In 1898, he found himself promoted to Inspector and subsequently transferred to Scotland Yard. By 1906 he'd become Chief Inspector. Dew had been involved in several high-profile cases and received many commendations, progressing his career within the force.

Hawley Harvey Crippen was an American doctor (although unlicensed in the UK), born in 1862. He moved to England in the 1900s and lived in the district of Holloway with his second wife Cora Turner, better known by her stage name, Belle Elmore. She had been previously described as somewhat overbearing, fond of fine jewellery and alcohol, and openly flirting with men. Although her theatrical singing career was remarked upon as mediocre, she gathered a devoted male following. Crippen, on the other hand, was a man of slight build, meek, and balding, with protruding eyes, which were exaggerated by his thin-framed round spectacles. They presented themselves as a mismatched pair by anyone's standards.

Crippen, constantly under his wife's thumb, turned his attentions and affections to his young secretary, Ethel Clara Le Neve. Cora is thought to have discovered her husband's indiscretions, or at least to have suspected it, threatening to leave him destitute in spite of her own barely disguised liaisons. Crippen's income was small compared to that of his wife, who could afford to indulge her extravagant tastes. A separation of any kind would not be favourable to the doctor.

In the early hours of the morning on 31 January, Cora and Hawley Crippen bade farewell to Mr Matinette, a retired music hall performer, and his wife as they left for home after a late dinner party. Unbeknown to them at the time, Cora would never be seen alive again. The next day, Crippen pawned a diamond ring and some earrings belonging to his wife for £80. A couple of days later, some colleagues of Cora received letters informing them that she'd unexpectedly left for America due to illness in the family there. It was noted that the handwriting wasn't that of Crippen's wife.

Suspicions were soon aroused. Ethel Le Neve had been seen wearing a brooch known to belong to Cora, as well as some of her clothes. It soon became clear that the young secretary had also moved in with Crippen. In March, Mrs Martinette received a telegram from Crippen, informing her that Cora had died while in America. It had been sent from the telegraph office at Victoria Railway Station. Crippen and Le Neve were on their way to France for a break – possibly to avoid awkward questions from his wife's friends.

A friend of Cora, Mr Nash, made a short trip to the USA but could find no trace of Cora. On his return, he visited Scotland Yard making his thoughts and those of other friends known to Chief Inspector Dew.

Dew interviewed Crippen regarding the disappearance of his wife. Crippen finally broke his story and admitted that Cora had in fact left him for someone else and they were thought to be living in Chicago. He said he'd been loath to admit this embarrassing situation and was trying to save face. Dew, not totally convinced, arranged a search warrant and visited the property. Nothing untoward could be found. The inspector decided that Crippen's story was plausible and reasoned it unlikely that this small, mild-mannered man would be capable of any crime. Shortly afterwards, Crippen and Le Neve left for Belgium. Dew returned to the property to clear up a couple of loose ends. On finding it empty, he instigated another search. Again, nothing was found. Not satisfied, they searched again and again until they discovered that some of the bricks making up the floor of the coal cellar had been disturbed. Underneath they found Cora, or at least parts of her, wrapped in pyjamas that were later proven to have belonged to her husband.

Inspector Dew released a description of the couple, which was widely circulated. Whether news that they were wanted in connection with the murder of Cora Crippen had reached the fleeing couple we don't know, but they boarded the *Montrose*, a ship bound for Canada. Unfortunately for them, the captain had suspicions about a couple of his passengers. Before going out of range of land-based transmitters, he sent a wireless telegram to the British authorities, which read, 'Have strong suspicions that Crippen London cellar murderer and accomplice are among saloon passengers. Moustache taken off growing beard. Accomplice dressed as boy. Manner and build undoubtedly a girl.'

This would be the first incidence of the new ship-to-shore wireless being used to catch a criminal on the run. Dew, with incredible forethought, boarded the SS *Laurentic*, a much faster vessel heading for the same destination. The Inspector landed in Quebec well ahead of the *Montrose*. With the help of the Canadian authorities and safe in the knowledge that, unlike America, Canada still remained part of the Crown Dominion thus giving Dew the power of arrest and detainment, the Inspector disguised himself as a ship's pilot and boarded the *Montrose*. The captain, in on the ruse, invited Crippen and his young male companion to meet the pilot. Dew removed his cap and introduced himself with, 'Do you know me? I'm Inspector Dew from Scotland Yard.' Crippen responded with, 'Thank God it's over' and submitted himself to custody.

Hawley Crippen was found guilty of the murder of his wife Cora by a jury after no less than 27 minutes of deliberation. He was hanged at Pentonville Prison on 23 November that year. Le Neve was acquitted as an accessory after the fact. This case was also the first murder investigation for the now-famous forensic examiner, Bernard Spilsbury.

Walter Dew left the police force to become a Confidential Agent. He successfully sued several newspapers for libellous comments written during the Crippen case, being awarded substantial damages. After he retired, he ironically became an advisor to the press, giving his thoughts and opinions on crimes of the day. He released his autobiography, *I Caught Crippen*, in 1938.

Dew retired to Worthing and lived at No. 10 Belmont Road, a small bungalow he called The Wee Hoose. It was renamed Dew Cottage in his honour in 2005. Walter Dew is buried in Durrington Cemetery, section fifteen, row five.

There is one more Worthing connection that has so far puzzled us. Councillor Francis Tate, of Francis Tate Monumental Masons, is said to have fashioned a headstone out of Greek marble for the grave of Cora. The stone is inscribed, 'In Memoriam, Cora Crippen (Belle Elmore), who passed away on 1 Feb 1910. Rest in Peace.' We are unclear as to whether Tate was commissioned to create the headstone or if he volunteered, and if so, why? Was he perhaps one of her past admirers?

Size Isn't Everything

Being no larger than a domestic garage, this innocuous little building used to be the local village fire station.

Situated in South Street Tarring, leading to the heart of the village, it housed not a bright red engine but a simple four-wheeled cart surmounted by a double-ended see-saw-like handpump. The surrounding buildings at the time took up little more than a few acres and local residents and farm hands, acting as part-time volunteer firemen, would rush

West Tarring's fire station.

to pull the cart to the nearest well or pond by hand in the vague hope of saving the then mostly wooden buildings. It would be a lucky day when a horse could be found nearby and harnessed up. Just up the road is the George & Dragon pub, on the outside of which can still be seen the red and gold iron plaque (number 742498), issued by an insurance company to ensure the ragtag firemen would spare no effort in dousing the flames with suitable payment later. Adjacent buildings would be ignored in preference. Although undated, the plaque is thought to date to around 1700 and was issued by the Sun Fire Office which still exists today as the Sun Alliance.

DID YOU KNOW ?

The kerbstones lining each side of South Street have small square holes with a metal lining and, in some cases, an eyebolt and ring set flush within the granite surface. Everyone assumes they were the remnants of railing, but they'd be wrong. They were for shop awnings. Back in the days before extendable shop canopies were wound or pulled out, square metal rods around 7 feet tall were slid into reciprocal holes on the kerb and a canvas sheet hooked onto the front of the shop above the window, then draped forward over the rods. Guy ropes at the corners were then secured to the metal rings to prevent it flapping or blowing away. Further examples can be found in the High Street and on Marine Parade.

Tin Tabernacle

There are few circumstances where you could put together two unlikely words such as tin and tabernacle in a sentence, but here in Worthing you can – we've got one.

A tabernacle is defined in the dictionary as a Latin word meaning tent or hut. The word itself has obvious religious connotations, while tin implies something temporary, or even flimsy. Putting both together we end up with a tin church, and that's exactly what we have: a prefabricated ecclesiastical building made from corrugated galvanised iron. Called St Peter's, it stands in Furze Road, a stone's throw from Salvington Windmill. Constructed in 1928, it acts as a mission church for Durrington Parish. These tin structures were once far more commonplace than they are today. In fact, they are now a bit of a rarity in Britain. This example wasn't the first in the area but it is certainly the last, and fully functional too we should add. In addition to the tabernacle, there is a rendered brick tower standing next to it, adorned with a Christian cross. One might wonder why it wasn't incorporated into the building. The answer is simpler than you might suspect; it started life as a water tower, being present before the church was built.

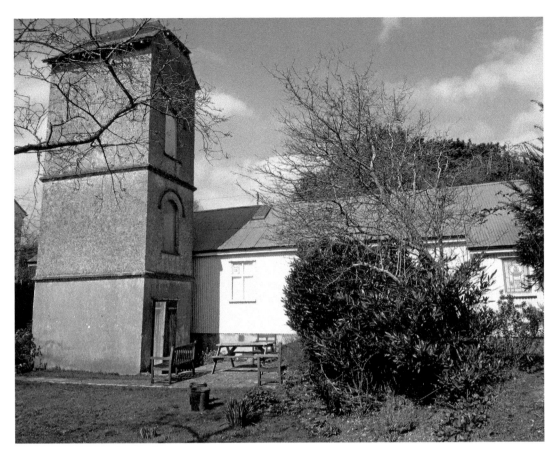

The Tin Tabernacle and the water tower.

Bomber Down

Halfway along the length of Worthing pier, screwed to an upright of the central windbreak, sits a plaque so easily missed. It is dedicated to the crew of a Lancaster bomber, all of whom perished on the beach a short stroll to the west from here.

The date was 17 December 1944; the mission, to bomb Munich. As with all sorties of this type, the aircraft was fully laden with approximately 90,000 lbs of explosives and fuel. Few realise the incredible strain and time it takes for such an aircraft to reach operational altitude, slowly gaining height while circling and playing out time for the others to catch up. Once the formation was established they would set off en route to their destination, weaving an erratic fuel-consuming course to throw off any attempt at tracking or predicting their final target.

Lancaster PB355 wasn't faring so well. For reasons still unknown to this day, the aircraft failed to maintain its altitude. Radio silence was broken as they informed 49 Squadron, RAF Fulbeck of their problem. The advice returned to the pilot was to jettison their bomb load over the sea and return to base – standard procedure in such events. This is also the reason that fishermen, even to this day, occasionally snag an unexploded bomb resting on the seabed.

By this time the aircraft had lost so much height that making it to the coast would have been almost impossible, and dropping its cargo over Sussex was unthinkable. Having reached Worthing, their altitude was now so low that releasing the bombs would have resulted in an explosion that would destroy the plane above.

In an effort to land safely, a beach landing was attempted. It had been suggested that a 'wheels up' approach would be best. It would be considered by most that landing with no wheels was in itself suicidal but experience had taught the RAF pilots that sand, dry or wet, was no friend to aircraft undercarriages. The risk of the plane tripping and cartwheeling across the beach, perhaps into the seafront buildings, wasn't an option the pilot was prepared to take, considering the payload.

At a few minutes to six that evening, Edward Essenhigh, flight officer, brought his aircraft down. He would only get one attempt – his crippled craft lacked the power to make a pass. What happened next isn't clear. As with all of the beaches along the south coast at the time, it was heavily fortified. It is thought that the Lancaster may have struck such a defence or even one of the many stout wooden groynes. It exploded instantaneously. The aircraft was shredded, sending shrapnel and pebbles across the seafront and shattering hundreds of windows, but, amazingly, with no loss of civilian life. In fact, only three cases of injury were reported and these were minor considering what could have been.

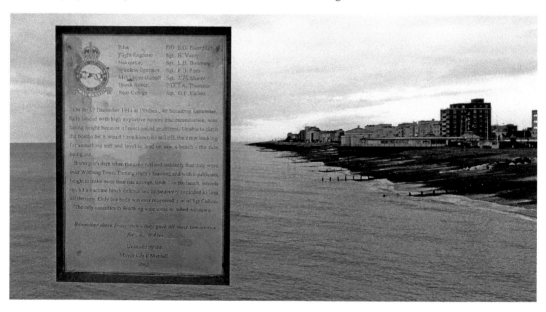

The coast west of Worthing Pier and plaque (*inset*).

An impression of the doomed Lancaster bomber.

The pilot and crew have been hailed as heroes. If it hadn't been for the skill and fighting determination of Essenhigh to keep the aircraft aloft for as long as possible, a major catastrophe could have ensued that would have destroyed a large area of West Worthing, with the loss of hundreds of civilian lives.

What remained of the Lancaster continued to burn uncontrollably and, little could be done. A lone figure could still be seen in what remained of the rear gun turret. Gorden Callon was undoubtedly dead but any attempt at reclaiming the body had to wait until the flames subsided; live ammunition was still exploding and the public were held back at a safe distance by the ARP.

The crash site was cordoned off and the shattered remains of the aircraft were taken away. An intensive search was made for the rest of the crew but only a few fragments were found. Gorden Callon is buried in Littlehampton Cemetery. The rest are commemorated at Runnymede. Occasionally small fragments of aluminium and steel turn up along the coast, a grim reminder of these terrible days.

In celebration of these heroic men, streets in the town have been named in their honour. These are: Essenhigh Drive (pilot), Varey Road (flight engineer), Bourne Close (navigator), Moore Close (air gunner), Thompson Close (bomb aimer), Callon Close (air gunner) and Rees Close (radio operator). There is also a Fulbeck Avenue, named after the squadron, along with Squadron Drive. It is interesting to note that all these roads link or spur off one another.

A Near Miss

Worthing wasn't exactly what you would call on the front line during the Second World War, but it did have its fair share of the action. There are a few residents of Worthing around today that will tell you stories of dogfights over the Downs and the Channel, along with tales of German aircraft machine gunning the streets. These aside, the town does bear some scars.

Bomb sites within the town are fairly well known, perhaps the most famous is just west of the Selden Arms pub in Lyndhurst Road, a gap between the terraced houses on the north side bearing testimony to how near the Germans came to destroying the adjacent gas tower.

The shooting down of a Heinkel 111P bomber on 16 August 1940 has been well documented by Graham Lelliott in his book, *A German Bomber On English Soil*, but there is another lesser known instance of a German bomber, also a Heinkel 111, that came down on 9 August 1942 in Lyndhurst Road, almost hitting Worthing Hospital. Perhaps the story is best told by Winifrid Houghton, a second year student nurse at the time. On duty that night in the hospital, in a newspaper article many years later she recalls:

> I hurried to the hospital windows overlooking Beach House Park in time to see an aircraft cross diagonally from the direction of the pier towards the north end of Madeira Avenue. I was amazed it had not struck the gasometer on its approach and I shall never forget that its landing lights were showing up in the bright sunshine. The plane somehow missed the roofs of Madeira Avenue houses and, with a sudden loss of power, it crashed through part of the flint wall on the south side of Lyndhurst Road behind which now stands the St. John Ambulance Headquarters.
>
> Crossing Lyndhurst Road, the aircraft buried itself with a great explosion in the

An impression of the Heinkel 111P bomber.

front of Dr Margery Davies's house and surgery, on the corner of Homefield Road. There were four Canadian soldiers billeted on the top floor and spilled fuel from the bomber's tanks set this floor alight. The men were brought to the hospital with severe burns. I believe they eventually died from their injuries.

Although several bombs on board exploded, some failed to go off and the area was sealed until bomb disposal men could remove the remainder.

In 1982, the *Worthing Herald* ran a feature on the event, reporting that two members of Dr Margery Davies' domestic staff had narrowly escaped death.

Eva Collins and Carol Wilson were in different parts of the house when the bomber struck the building. Carol immediately rushed to Eva's room at the back of the house and helped her out, but on reaching the staircase they found it a mass of flames.

Running to an upper window at the front, their shouts for help were heard by soldiers who were tackling a blaze that had also broken out in the house next door.

The soldiers shouted to the women to jump and as they did so the troops caught them, with no injuries to the women.

As they huddled against a wall their one thought was for the doctor's car, which was now in flames. The soldiers searched through the debris for any other trapped occupants. Some lifted flaming beams of wood with their bare hands and had to be treated for burns at the hospital.

The article goes on to detail an account from a resident who was visiting a house 150 yards away:

We were engaged in a heated discussion on Einstein's Theory of Relativity when there was a loud wumff. Going in to the street we saw an enormous blaze. The large house and big trees surrounding it were burning furiously. Here and there were rivers of

The wall in Lynhurst Road, with visible repair work.

flame and the road and shrubs were festooned with ribbons of fire.

The aircraft was apparently blown into so many pieces that it was not immediately recognised as a German Heinkel 111. Had it come down just 50 yards further north, it would have destroyed the children's ward in Park Road. It being a Sunday also helped to minimise the casualties. In fact, there were no civilian injuries. The four-man bomber crew, however, were all killed, as were four Canadian soldiers billeted in the doctor's house. The death of these soldiers, due to wartime censorship, was not reported in newspapers at the time.

Heene in Ruins

St Botolph's Church has sat comfortably in the quiet, leafy back streets of Heene since the late nineteenth century. It was only natural that this developing community had its own place of worship, but unbeknown to many, it wasn't the first one on that site.

Rarely does anyone take the time to walk around a church these days. St Botolph's notably lacks the entertainment factor of a graveyard, reminding you of lives past with ornate inscriptions and fading kind words – you'd be wrong to assume that, but we'll tell you why later. Meanwhile, take the opportunity to explore the eastern face of the building and you'll discover the ruins of what is believed to be an old thirteenth-century chapelry, a word defined as 'served by an Anglican chapel'.

What remains of the structure today is very little in comparison to its original size. It existed up until 1766, when permission was granted to slowly dismantle it as no formal services had been held there for over eighty years. It was noted that a 'handsome stone window' was pulled down as late as 1892 as it had become a danger to life. Our picture clearly shows where it once rested.

We are led to understand that much of the masonry was used to repair and maintain St Andrew's Church in West Tarring, which at the time was Worthing's primary place of worship.

The chapelry's decline could partly be attributed to the 1773 Inclosure Act (now written as Enclosure), where landowners and lords of the manor effectively fenced-off common land or wasteland as their own, removing tenants and landless peasants, cutting down the already small population.

Now, back to that missing graveyard. Formally known as Heene Cemetery, it rests on the corner of St Michael's Road and Manor Road. It is surrounded on one side by houses, on a second by mature trees and on the third and fourth by a tall wall, making it easy to stroll past without noticing its existence. Although a closed site these days, it is being maintained as a designated site for nature conservation.

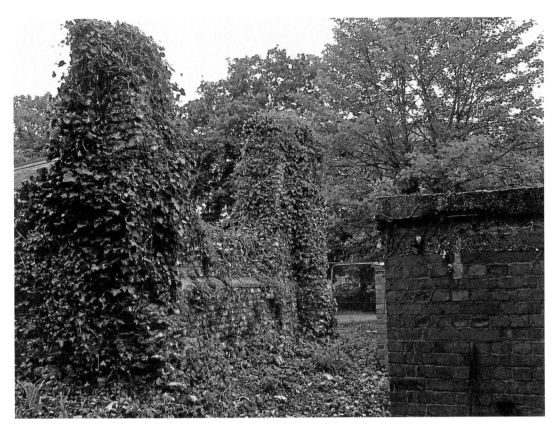

The ruins of Heene Chapel.

Beach House

Beach House has been the backdrop of hundreds, if not thousands, of family holiday photographs over the years. Although it's hardly hidden or secret, it does have a story to tell.

Standing between Brighton Road and the seafront, this regency building (erected in 1820) remains one of the last of its kind in Worthing. The property has had an enviable resident and guest list, including a king and many luminaries. It is adorned with no less than three blue plaques, which, due to their position in a private car park, don't invite closer inspection.

Famed London architect John Rebecca was behind the design for the building, as well as many others in town. Rebecca was also responsible for the construction of Castle Goring, which he designed for Sir Bysshe Shelley. It was intended for his grandson, Percy Bysshe Shelley, the poet who had family interests in Worthing. In fact, two of Shelley's early works were printed in Warwick Street – a blue plaque above the Warwick pub commemorates this.

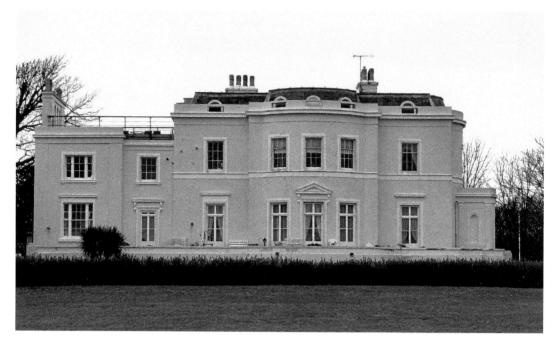

Beach House – image taken from the south, looking north.

It was perhaps Beach House's second owner who began making this property desirable to the more well known. This honour fell to Sir Frederick Adair Roe, head of the Bow Street Runners – London's first professional police force. Next came Sir Robert Loder, Conservative MP for New Shoreham (now Shoreham-By-Sea), and later passed on to his son Sir Edmund Giles Loder on his death. It was Sir Edmund who is said to have entertained and boarded Edward VII here on many occasions between 1907 and 1910 although oddly, no connection between the two has ever been proven and therefore is deemed unlikely to have happened.

When Sir Edmund moved on, he offered the building for sale to Worthing Borough Council, who, for unknown reasons declined, leaving the building unoccupied for some years. A brief respite occurred for a while during the First World War when it was used by refugees as a doll factory to keep them usefully employed.

1917 saw a new lease of life for the Beach House as the playwright Edward Knoblock, author of the play *Kismet* (this became an award-winning musical on Broadway in 1953), purchased the building as his home from the profits. Here he is said to have entertained the likes of Arnold Bennet, J. B. Priestley and Sir Compton Mackenzie.

Eventually, in 1927, Worthing Corporation purchased the building, later using it as a temporary town hall while a new one was erected. The new town hall opened in Chapel Road in 1933, replacing the original built in 1835 that once occupied the site just outside the Guildbourne Centre in South Street.

The year 1936 saw Beach House used as an evacuation and quarantine centre for Spanish children relocated from the Basque region during the civil war. They were supported on an entirely voluntary basis by the town's residents and traders. Later, the council wanted

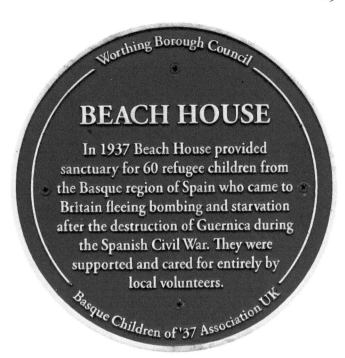

Worthing Borough Council

BEACH HOUSE

In 1937 Beach House provided sanctuary for 60 refugee children from the Basque region of Spain who came to Britain fleeing bombing and starvation after the destruction of Guernica during the Spanish Civil War. They were supported and cared for entirely by local volunteers.

Basque Children of '37 Association UK

One of three plaques on Beach House.

to demolish the building but local opposition led by the inimitable Pat Baring, a stalwart conservationist, won through. Although a preservation order was served, the building was allowed to fall into neglect by the council, possibly in the hope of it becoming dangerous so demolition would be inevitable.

In 1987, it was purchased by a private buyer and converted into flats. To its credit it is well maintained, earning a Grade II-listed building status. Each flat and car parking space is named after its famous residents and guests as a reminder, though few would recognise the names today – perhaps the parking space marked 'Windsor' might give a clue.

Beach House Park

Like Beach House, the gardens aren't a secret in themselves, being the past venue to the World Bowls Championships, but they are home to a couple of oddities: one is the bird memorial, mentioned elsewhere within these pages, but the other is far less obvious. This elegant and well-managed park and gardens have both a north and south entrance. The southerly one is the more ornate, its large iron gates being supported by two pillars bearing the carved legend 'Beach House Park'. The odd thing here is that the gates have the initials 'GA' gold painted within the framework, strangely out of sorts with the park's name.

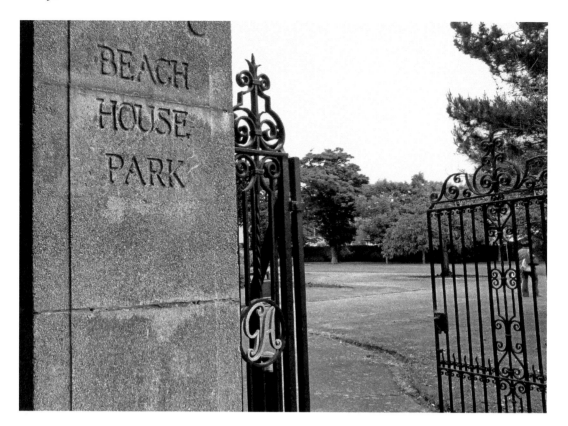

Beach House's gates with 'GA' inset in the iron work.

OK, we'll be honest; the gates have been recycled from elsewhere. They originally stood at the entrance to the Warren School in Offington, near Broadwater. The initials stand for Gertrude Ashworth, headmistress there for thirty-seven years; the gates were custom made in 1951 in her memory.

When the school closed in 1966, the estate was purchased by the Excess Insurance Company who demolished the Gothic mansion in 1972 but thankfully left the lodge house intact. This flint and block building can still be seen by those travelling between the Grove Lodge and Offington roundabouts. The original entrance next to the lodge, although now bricked up, is still discernible.

There is a book, written by David A. Cross, on the life of Gertrude Ashworth with the rather ominous title *Churchill in Petticoats*, but this has proved to be difficult to find. However, a good description of life at the school is given by the actress Pam St Clement in her book *The End of an Earring*. A boarder there for many years, she found her love for acting in drama class. We know her better as Pat Butcher in *Eastenders*.

Underneath the Arches

There is next to no information about these unusual features, possibly because they are unique to Worthing. The design derives its name from the resemblance to the outline of a boat, a common sight in a seaside fishing village even to this day, but why they only appear in our town remains a mystery. The style is known architecturally as ogee – a gentle symmetrical arch that suddenly peaks at the apex. In itself it's not that unusual when used as window or door frames, but these are more likely to be found on more ornate buildings. Ours differ considerably as they protrude out some 2 or more feet and encase a simple small front door. The buildings they adorn aren't particularly rich in design, which makes these even more unusual. Those in Warwick Place, the first to be built around 1841, are little more than terraced cottages, typically home to local fishermen. Alfred Place across the road, built between 1826 and 1843, has four in a line, while the rest of the buildings of almost identical design have none. Portland Road some distance away, has just three. We might assume that these were all constructed by the same builder and his eventual death brought an end to his artistic flair.

Boat House arches in Warwick Place.

Mill on the Move

One thing you don't expect to see after spending an evening imbibing at the local hostelry is a windmill outside the front door – especially when it wasn't there when you went in – but that's what happened in 1877 for the drinkers at the Anchor Inn in Lyndhurst Road.

Cross Street Windmill, or as it was earlier known, Teville Windmill, built around 1805, sat neatly on the rise of the gentle hill that is Worthing – a position that gained the best advantage of the sea breezes. Before it, was Teville Common, a land devoid of anything that would hinder the coastal winds. The owner, Thomas Moore, would have looked forward to a productive future for his bakery and confectionary shop in town.

In 1845 the railway came to Worthing and with it an influx of people eager to spend time at the seaside – a luxury ill-afforded in comfort prior to the introduction of the steam train. Inevitably, construction followed, giving birth to the early commuter and holidaymaker who could now take advantage of the sea view gained from a residence on the hill. This development would soon prove inconvenient for Edward Collins, a millwright from nearby West Tarring village and later owner of the Cross Street mill. The sea breeze that had been so instrumental in planning the mill's original positioning and production, had become disrupted as the common land between it and the coast became enveloped in buildings.

The solution to this dilemma was a simple one: move the mill closer to the sea. Edward was to oversee the task set before him. One major problem encountered was that the

DID YOU KNOW ?

The road bridge over the railway line in Goring Street (A259) was a bit of a late developer – by around fifty years. Two massive earth ramps each side of the line were constructed in preparation for the road bridge that was to act as an alternative route, avoiding the narrow road at Goring Station crossings. Work was halted by the intervention of the Second World War and it was finally completed half a century later.

structure was a post mill. There are two basic types of windmill: a smock or tower mill, where the top or cap turns to face the wind; and a post mill, where the whole structure rotates as it sits on a massive upright post, literally balancing on the top.

Over a period of time, the sails, millstones and anything else that wasn't permanently fixed or would threaten the integrity of the structure was removed and sent ahead. The now empty shell was laboriously jacked up and a flat-bed wagon slid underneath. A local contractor, by the name of Charles Poland, supplied the forty horses needed for the move. Ironically perhaps, it was the very growth of Worthing that was to prove to be the biggest hindrance. Once upon a time the journey would have been quite straightforward, but now more permanent roads were in place, making a snake-like route inevitable.

It was just beyond the junction of the High Street and Lyndhurst Road, where the Anchor pub lay, that was to prove to be their undoing, albeit a temporary one.

Sketch by Truefitt –
windmill on the move.

A sharp bend had been negotiated by the first twenty or so horses, but a train of beasts of such length made it impossible for them to pull evenly. Time eventually took its toll on the creatures. Now exhausted from their efforts, a halt was called, leaving the mill stranded outside the inn, much to the surprise of the patrons inside. Here it was to remain until the following morning. The distance covered so far was probably not even halfway.

The next day, in an effort to get things going more smoothly while saving Charles Poland's horses further distress, two traction engines were employed, along with their own flat wagon acquired from J. Holloway in nearby Shoreham-by-Sea. The mill was transferred and the journey continued without any more reported incidents. The mill's final resting place became known as Seamill Park Crescent, close to Seamill Park Avenue, which still remains today. Sadly, the mill was demolished in 1905. The illustration above was drawn by George Truefitt, a retired architect who had taken up sketching and watercolours in his leisure time and was fortunate enough to capture the scene.

A Little Eccentric

The name George Truefitt is unlikely to ring any bells with the residents of Heene these days. This short, quiet and unassuming man would hardly raise an eyebrow as he strolled along Worthing promenade with his granddaughter on his arm enjoying a warm summer evening. There was a lot more to this man than met the eye and it wasn't just his discreetly built-up heels, or the fact that the young woman on his arm was really his wife.

Truefitt was born in London on Valentine's Day, 1824. As an intelligent young man with an eye for design, he undertook an architectural apprenticeship from 1839 to 1844 under Lewis Cottingham, who pioneered the study of medieval Gothic architecture, a trend that can be seen reflected in his own work. During this time, he befriended fellow apprentice Calvert Vaux, who was to later become the co-designer of New York's Central Park. The two of them set off on a walking tour through France and Germany, making between 400 and 500 sketches along the way.

On Truefitt's return, he entered a competition to design the Army & Navy Club in Pall Mall. His drawings impressed Sir William Cunliffe-Brooks MP, for whom he would eventually work. In spite of his obvious talent, he didn't allow himself to be commissioned for work but preferred instead to enter by competition, not an uncommon practice at the time. In his working life, Truefitt designed 170 houses and mansions, forty-four cottages and lodge houses, eight rectories, seven schools, thirteen banks, along with seven large halls and church rooms.

Truefitt's structural legacies still stand today, spread around the country. Thankfully, Worthing has an example of his work – St George's parish church in St George's Road, East Worthing. Built in 1868 at a cost of around £5000, it was designed with a Gothic style in mind. Unusually for a church, it has a north-south alignment. It is also noted that the roof resembles the upturned hull of a boat. Perhaps George had a whimsical moment – we will never know.

George retired to Worthing and purchased Shelsley Lodge, just off the seafront, on the corner of Western Place and Western Road. However, for a man who had spent a lifetime designing buildings, this retirement wasn't to last. It was inevitable that he would keep his eyes open for something more challenging. This would present itself in the form of the Old House, as it was known in Heene Road. George claimed that the ruinous buildings that occupied the land had originally been monastic in nature and featured a 'fives court'. This was a ball game not dissimilar from today's game of squash but using the hands instead of racquets. It was commonly played between the buttresses of a church building which formed the playing area.

George went on to design a house on the site, incorporating part of the original structure, ensuring all the main rooms had a favoured southern aspect. As a result, the front door was situated on the north side, an unusual but practical choice. He and his family took up residence in July 1893. Sadly, the Old House is no more and despite further research, its exact location still remains unknown, other than a single clue – it had a northerly view of Skinner's Farm on the corner of Cowper Road, placing it within a stone's throw of St Botolph's Church.

Truefitt was, by all accounts, a typical Victorian gentleman in character: strict with high principles, so much so that when he married a young Brighton woman of twenty-six years, it would have shocked the local community, especially as he was seventy-one at the time. This was his second marriage. His first wife died in September 1896, with whom he had three children, the youngest of which was already ten years older than their new stepmother.

We are fortunate that George Truefitt left a legacy of detailed sketches and watercolours of Worthing, which included Heene, West Tarring and the seafront. Truefitt died on 11 August 1902, aged seventy-eight. He and Mary, his first wife, are buried in Heene Churchyard, a short distance from their home.

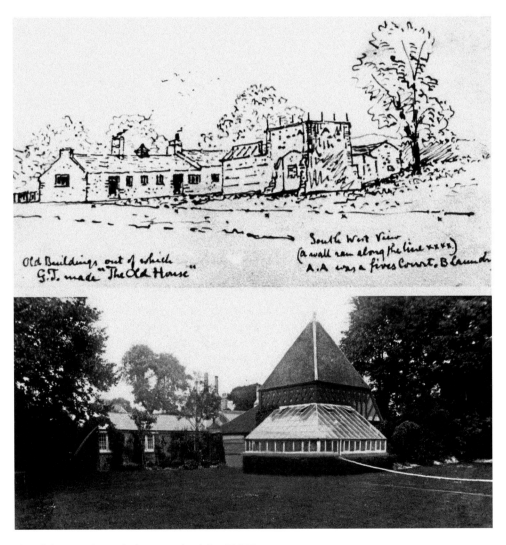

Sketch by Truefitt and photograph of the Old House.

Quart into a Pint Pot

At the top of Chapel Road stands Bunce's, a well-respected hardware store. It rests on the site of the old Clock Brewery which held a little secret – only it wasn't so little.

The land, a large plot at the time, was home to a malthouse owned by a Mr Mitchell and later sold to the Allen brothers, Alfred and Dennett, around 1851. The brothers were wealthy land and business owners with property consisting of six houses, four cottages, two farms, seven malthouses and a brewery, all located in Sussex. It was the brewery in Worthing that was to lead to their eventual downfall.

The brothers had been very successful, making considerable sums of money, much to the annoyance of other traders in similar goods. They purchased barley grain at a high price, often outbidding their rivals, some of whom eventually went out of business. The finished malt, although of good quality but not exceptional, was readily purchased in favour of the others.

Suspicion became aroused among the few remaining competitors. Locally, the Allen brothers could do no wrong. The farmers were happy and their own employees paid a wage better than most for the period. It could only be a matter of time before the truth would come out.

It became a necessity that the brothers' secret became shared with a selection of trusted employees, their cooperation being essential to enable the good fortune to

DID YOU KNOW ?

The Clock Brewery and Malthouse were the first public buildings in Worthing to display a clock outside. Bunce's has carried on this tradition. The original clock became the property of Wenban-Smith, the timber merchants, and was last seen in the 1970s. No trace has been found since.

continue. One of the Worthing brewery employees sought to take advantage of his new-found knowledge and attempted to blackmail the brothers. His plan was to go into business for himself, funded by the Allen's money and a promise to keep the secret of their success. The brothers, not ones to allow themselves to be held over a barrel, dismissed the man. Perhaps they reasoned they could call his bluff in the assured knowledge that exposure would result in his fellow workers becoming unemployed and the loss of business would be detrimental to the local economy. The obviously disgruntled ex-employee, whose name remains unknown to this day, knew that by revealing the secret, he would be exposing himself and his family to possibly dire consequences. With this in mind, he elected instead to anonymously hint that all was not as it seemed to the excise authorities.

It is recorded that on Tuesday 31 March 1857, at 4.00 a.m., revenue officers paid a surprise visit and for five hours searched every corner of the malthouse while other

officials examined the books. Having found nothing untoward and possibly starting to believe they'd been sent on a wild goose chase by a disgruntled business rival, the revenue men made a move to leave when one of the officers noted one of the Allen brothers glancing at a wall next to a malting kiln.

Closer examination revealed soft mortar blended in with the surrounding brickwork. Tracing around a square shape in the wall exposed an iron frame with bricks set within. This cleverly disguised hatchway could be quickly removed and replaced, with only the need to apply a weak mortar mix around the perimeter to render it invisible – the lack of any strong light inside was sufficient to hide it from the naked eye.

Climbing through the now-exposed hole revealed a short downward passageway which led to a cavernous, solidly built underground vault that rested between the two malthouses above, both of which had submerged ground floors, allowing this unseen secret connection to take place. The contents of the cavern were malted barley in equal amounts to that above. It became clear that the Allen brothers sold one untaxed sack of malt with every genuine sale. This trading enabled a good profit, while the books gave the impression of a sufficient one.

News of the raid soon spread as the revenue officers made their way to the other buildings owned by the Allen brothers across Sussex. At each location they found an identical set-up in place. Not all were caught red-handed: the Horsham brewery apparently managed to sneak out the excess malt and dumped it in the river, much to the joy of local farmers who scooped it up in quantity to feed their pigs, or so the story tells.

The Allens being duly apprehended, were later summonsed to appear before the King's Bench on 16 June in that year. The authorities knew that, given the circumstances of defrauding His Majesty's Government, there would be a possibility that both Alfred and Dennett might consider leaving the country as the court day approached. To this end, both remained under a watchful eye. This proved to be of no avail, as the pair managed to slip away and board a steamer bound for France. Detectives, alerted to this fact, followed closely behind and on landing made directly for Paris. Unknown to them, the brothers proved to be far more cunning: doubling back almost immediately and travelling onwards to London, leaving the police running up a dead end. Back in the city, the Allen's booked themselves onto an express train bound for Liverpool and then by ship to America.

The hearing was held in spite of their lack of attendance and no defence could be offered against the thirty charges brought against them. The jury had no option but to find the accused pair guilty of all charges in their absence. Although the loss of income to the government by non-payment of tax due was calculated to be in excess of £350,000, a reduced fine of £110,000 was levied.

Fortunately for the Allen brothers, (or perhaps they were already aware), America had no agreement with the UK to extradite in cases of fraud and so they remained safe. Steps had also been taken in advance to disperse all property ownership to close family members, thus avoiding confiscation. After spending a comfortable time in North America, they were informed that the Solicitor General had reconsidered the case and was prepared to reduce the fine to that of £10,000, reasoning that something was better than nothing. With

this agreement in hand, the brothers returned home free men and continued their lives as before, assumedly following a more law-abiding path.

Today, if you walk up Lennox Road on the south side of Bunce's and peer over the yard wall at the rear, you can still see some buildings that date back to the Clock Brewery period. Local knowledge suggests that recent ground works in the yard area failed to turn up any evidence of the vault as it was collapsed in on itself and filled in to avoid further temptation.

DID YOU KNOW ?

It wwould be difficult to walk around in any town of a reasonable size and age not to find a 'Malthouse Cottage' or 'Barn' – Worthing had several. These buildings were prolific and played an essential part in both the brewing industry and local economy.

In order to make the barley viable for brewing, each individual husk needed to be split open – this is where the malthouse came into play. Generally, these buildings were long barn-like structures with two or more floors. The barley corns were spread evenly across the floor and soaked with water to encourage germination. Each day they would need to be turned and raked to ensure this happened uniformly. Once the seed case had split open and the beginnings of a shoot appeared, they would be dried using hot air or an oven to prevent further growth. Now they were ready to be sold on to brewers to make beer or whiskey. Note: If dried in ovens, the more they are toasted, the deeper the colour and the darker the beer. Although often associated with beer, malt was used in many other food products such as bread, biscuits, vinegar and even today's Maltesers (there's a clue in the name).

Worthing's Pier Group

Worthing almost had a second pier – it's true. No, not the Lido, although that did once try to claim fame as being the shortest pier in the country. The site of Worthing's second pier is not immediately obvious, although if you know where to look, it becomes apparent. The map shown is taken from material published at the time to promote the project.

Worthing town was expanding rapidly outward in the late 1800s and West Worthing, a separate entity at the time, was to follow suit. A map from 1879 shows that new roads were already in place but with houses yet to be built. One tree-lined road, noticeably broader than most, formed the western boundary of the planned development – it was known as ladies mile. It ran from Tarring Road in the north, down to West Parade and the promenade. The seafront end (unsurprisingly) is where the proposed site of the second

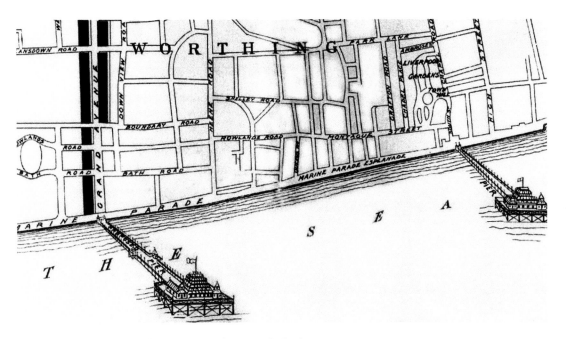

Illustration showing how the second pier might look in situ.

pier can be found. The road itself later became Grand Avenue. It is easy to imagine the grandeur of this area during the late nineteenth century as large villa-styled houses started to grace the surrounding land. Today many have been demolished, replaced by modern flats and apartments.

The raised seafront promenade, which runs almost the entire length of the Worthing coastline, is accessible via steps and some well-placed ramps along its route, but directly opposite Grand Avenue there is a marked difference. Here we find a set of broad steps surmounted with four tall lanterns followed by a large paved semi-circle. Built around 1893, this was the approach designed as the entrance to the second pier. Unfortunately, the funding was not readily forthcoming to complete what would have been a fantastic addition to the town, rivalling nearby Brighton with its own two piers, and sadly the project was abandoned.

The pier was only half of the planned development at the time; the other half was the construction of the Hotel Metropole, to be situated on the south-west corner of Grand Avenue, overlooking the sea. It is fair to say that this project did get off the ground, but only the eastern side of the building was constructed, facing onto Grand Avenue itself. The front, along with the west wing, never saw the light of day, a victim of a short economic depression that sounded the death knell of the pier. Thirty years later in 1923, work began again, but only to convert what had been built into apartments which became known as 'The Towers'. It was renamed Dolphin Lodge in 1971.

With the certain knowledge that the matching front and east wing would never be built, the land was sold off for development and the somewhat out of tune block of flats now fronts the building. One can't help but wonder what would have happened if the Hotel

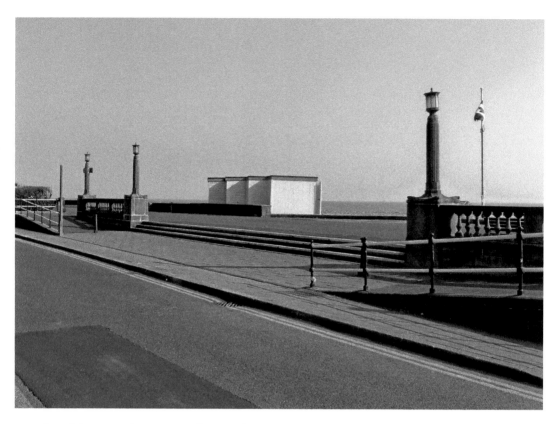

Grand Avenue and entrance to the second pier.

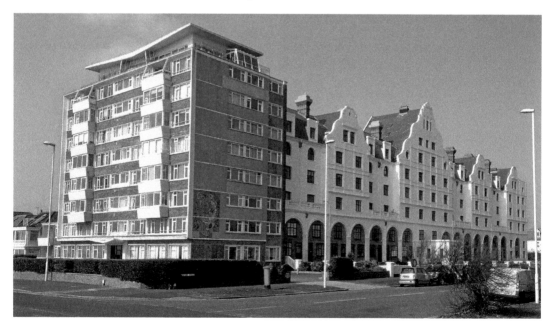

Dolphin Lodge with a modern tower block.

Metropole had seen the light of day in its final form. We assume that the gap between Grand Avenue and Heene Road would now resemble the splendid buildings on Brighton seafront, rather than the collection of generic tower blocks there today.

DID YOU KNOW ?

Close to the bottom of Grand Avenue, on the junction of Bath Road, stands Black Nest Hall, a rather stunning and substantial building resembling a barn in shape. Originally built in 1728 in Dunsfold, Surrey, two enthusiastic architects (C. P. Munn and A. Beresford Pite) decided to move it piece by piece to Worthing in 1926. The structure was given a mock Tudor look which had become a popular trend in the inter-war period. Several additions have been made over the recent decades but remained in keeping with the structure.

Sherlock Holmes in Spirit

What dastardly mystery would bring Arthur Conan Doyle, creator of the great detective Sherlock Holmes, to the sunny shores of Worthing? A spiritual one it would seem.

Conan Doyle, (second from the left in the image overleaf), was a firm believer in spiritualism, something he had turned to after the death of his wife and many family members between 1906 and 1918. He was also a member of The Ghost Club, an organisation established to prove (or disprove) alleged paranormal activities.

Conan Doyle wasn't a stranger to Worthing. He delivered a lecture on spiritualism at the Connaught Building in July 1919, attended by the mayor, who had the grand name of Farquharson White.

Conan Doyle returned to Worthing to open the art nouveau spiritualist church in Grafton Road on 24 March 1926, although the church had been in use before that date. The image records that event. The building has recently had a facelift but a plaque commemorating the event still remains on the outside wall.

It is perhaps surprising to think that a man such as Conan Doyle, obviously very precise in his studies, believed so firmly in spiritualism. Clearly he sought answers and like any good detective, left no avenue unexplored.

In an ironic twist, when he died in Crowborough on 7 July 1930, as a non-Christian, he requested that he be buried in Minstead, in the New Forest, just outside of the churchyard itself. Later, the churchyard was extended and Sir Arthur now lies within its boundary – not too sure how he would feel about that.

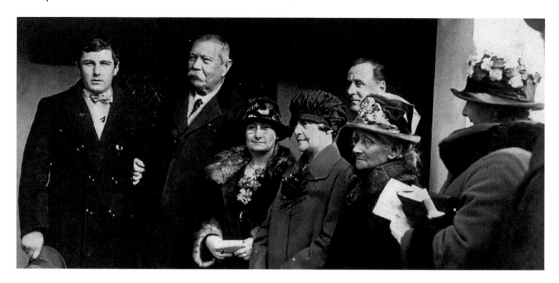

Taken at the Arthur Conan Doyle Worthing Spiritual Church.

Please Sir, Can I Have Some More?

The Victorians, in their wisdom, were perhaps not the most charitable when it came to providing for the poor and needy. Workhouses provided food, shelter and of course work for those who really had nowhere else to go, these were often seen as the idle or 'undeserving' poor, a choice of last resort. For the more 'deserving' poor, those that had fallen on temporary hard times, perhaps due to family circumstances or brief unemployment, there were soup kitchens – and Worthing had its own.

Purpose-built and opened in 1892 in Grafton Road by the Provident and Relief Benefit Society, it operated until 1924.

Here the down-on-their-luck locals could attend and be served a bowl of heart-warming fare at no cost to themselves. The timing of its construction could not have been better placed, for just a year later in 1893 the town was hit by a typhoid epidemic, heavily increasing the need for sustenance among the working classes as well as the poor. It was noted in August of that year that some 200 lbs (90 kg) of beef was being used daily to make beef tea.

Since its closure, the structure has been put to a number of uses – many locals will remember it as a garage providing car repairs. Closer inspection of the frontage reveals much of it has been reinstated after the garage business closed. Currently, the building is a private school (2016).

It was during renovation in the 1980s that an interesting discovery was made. Hidden in a crevice within the old kitchen area, a piece of paper was found, put there by some

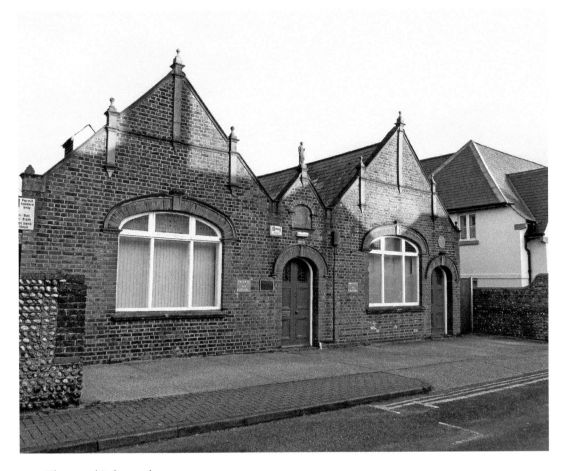

The soup kitchen today.

forward-thinking worker in the fabric of the building for future generations to discover. On this paper was the original recipe for the soup on offer.

Of course, the temptation was too much to resist with someone duly following the recipe, providing an insight into Victorian charity. The food was found to be not so much a soup as a mutton and pearl barley stew. A pretty bland and tasteless mixture with no salt added, it was clearly designed to fill the bellies of the needy in the hope that they would not return for more.

It is interesting to note that although the soup kitchen closed as a concern in 1924, the need for such a service arose again just prior to the Second World War. This original soup kitchen was not reopened, instead another operated from a site in Ivy Arch Road, although its exact position, to the authors at least, is not known.

Yellow With Age?

There cannot be many town centre buildings that stand almost unknown among locals, but Bedford Cottage is one.

This Grade II-listed building can be found tucked away in the corner of a car park at the south end of Marine Place. Bedford Cottage is one of the very few buildings that date to the time when Worthing began to slowly emerge as a seaside resort following the visit of Princess Amelia in 1798.

Built around 1800, it is constructed from brick and flint with a slate roof. Flint, of course, would have been an obvious choice for building material as an ample supply was literally a stone's throw away. Of particular interest is the use of a unique 'Worthing brick', with its distinctive yellow-orange colour.

1988 saw the cottage and other buildings surrounding it – Bedford Row included – threatened with demolition by a local chain store wishing to extend their footprint. Thankfully, during lengthy planning negotiations, someone had the foresight to get the building Grade II-listed, thus helping to save it. All development plans for the area were subsequently dropped.

So why 'Worthing brick' you may ask. Long before the promenade appeared in 1821, an expanse of salt grass could be found reaching out from the shore to at least the end of the

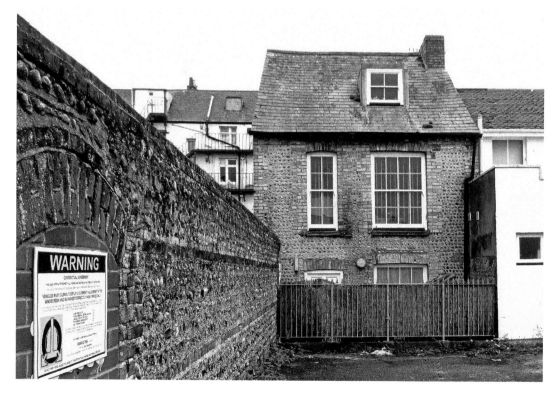

Bedford Cottage, hidden in a car park.

pier and around 1.5 miles wide. Back then, there were no water breaks to protect the land and as the sea set about eroding the shoreline, a seam of purple clay was revealed beneath the salt grass. It was this clay, when dug and fired for use in construction, which gives the brick its distinctive yellow-orange colour.

The digging of the clay, of course, only served to increase the rate of erosion before it finally disappeared altogether around the late 1840s. We know this from looking at buildings around the town; Christ Church, built in 1843, is one of the last buildings to be constructed within the town that contained any of this brick.

It is also worth noting that the brick seems to have been highly desirable and used only in the finest and higher status buildings. A casual stroll round the town will reveal this: St Paul's Chapel, Bedford Row, The Hollies in Little High Street and the old Henty Bank (now the Vintner's Arms in Warwick Street) are just some of the buildings faced with, or completely constructed, using this brick. The brick is not just confined to Worthing, it can also be found in Chichester.

Speculation surrounds the use of Bedford Cottage. It has been suggested that it was once a fisherman's dwelling, but doubt has been cast on this; at the turn of the nineteenth century, this was a highly fashionable area and it is likely that the cottage was built for the more well-to-do residents of the town, or even for a wealthy visitor as a holiday home.

Standing immediately to the south is Threadpaper House, a building of similar construction and age that faces the sea. Viewed from the front, it is set back from the street, squashed between adjacent buildings – a rather pleasing bow-fronted structure. Viewed from the rear, the fabric of the building becomes visible, revealing the same flint and yellow brick construction.

DID YOU KNOW ?

Remember those wondrous days as a child when a new box of cornflakes was opened and we'd plunge our hand in looking for that week's novelty toy? Back in 1961 Kellogg's went one step further – you could win a 'House-by-the-sea.' These were brand new purpose-built houses, each fitted with all the mod cons of the day. Four of these homes are in Worthing. One is at the southern end of Stone Lane and the other three, we believe, but it is as yet unconfirmed, are in Anscombe Close just off the seafront. Today you would be hard-pressed to identify them; despite their modern design they did eventually blend in.

Lights, Camera, Action

Worthing is a typical seaside resort and as such lends itself well to certain genres of film and TV programmes, both nostalgic and otherwise.

The comedy/drama *Wish You Were Here*, starring Emily Lloyd and Tom Bell, filmed in 1987, is possibly the best remembered. Set in the 1950s, it tells the story of a naive but saucy young sixteen-year-old, Linda Mansell (Emily Lloyd), and is said to be loosely based on the early life of Madam Cynthia Payne, aka Miss Whiplash, who was born in Bognor Regis. Filming centred on Worthing, with extra scenes from Brighton and Bognor. Notable locations include the iconic Dome Cinema, both inside and out; the walk over on the south side of Beach House (near what used to be Peter Pan's playground); three shops in Rowland's Road; the Southdown Bus Depot (now Stagecoach) and Linda's fictitious home in York Road. The film was written and directed by David Leland and won an award at the Cannes Film Festival in 1987 and a BAFTA for Best Screenplay. Interestingly, Emily Lloyd is the daughter of Roger Lloyd-Pack who played Trigger in the TV series *Only Fools and Horses* starring David Jason, whose brother lived in Worthing. Emily's mother was a personal assistant to Harold Pinter, playwright, actor and director, who lived in Ambrose Place for a short while.

On the subject of Pinter, his much acclaimed play *The Birthday Party* (1968), set in a rundown boarding house on the south coast, was filmed here – thankfully just the external scenes.

Dance With A Stranger (1985), starring Miranda Richardson, Rupert Everett, Ian Holm and Stratford Johns was loosely based on the story of Ruth Ellis, the last woman hanged in the Britain. Scenes feature the beach at Marine Parade with the pier and pavilion theatre providing the backdrop.

Up the Junction (1968), starring Dennis Waterman, Suzy Kendall, Adrienne Posta, Maureen Lipman and Liz Fraser tells the story of a well-to-do young lady becoming friends with a couple of working-class girls. In it, a planned dirty weekend takes place here in Worthing, stealing Brighton's usual limelight for 'that sort of thing' – Denis Waterman is recorded driving his sports car along the seafront looking for the hotel. In one promenade scene, a jellied eel stall made an appearance, something Worthing has never indulged in to our knowledge.

Of a more factual nature is the BBC 1 series *Who Do You Think You Are?* One episode features Martin Freeman tracing his great-grandfather, Richard Freeman, a blind organist, piano tuner and choir master at St Andrew's Church in West Tarring.

Comedy-wise, the cast of television show *Men Behaving Badly* shot episode forty-one, 'Gary in Love', on the seafront, pier and local café. The Eardley Hotel, demolished in 2008, was amusingly renamed the Groyne View Hotel, while a section of Splashpoint was transformed into a miniature golf course.

Martin Clunes, one of the stars of the above show, and more recently appearing as the grumpy Dr Ellingham in *Doc Martin*, made a notable appearance completely naked on Worthing seafront close to Sea Lane Café in 2008. Not a naturist gone astray, but rather a sequence filmed for the remake of the 1970s comedy series *The Fall and Rise of*

Reginald Perrin. We should perhaps add that a body double was used for the somewhat cheeky scene.

Little known these days, Nancy Price, born Lillian Nancy Bache Price in Staffordshire in 1880, became a specialised Shakespearian actress playing at many of the well-known London theatres. In 1930 she helped form the People's National Theatre, based in the Adelphi, before its demise in 1941 due to bomb damage. Undeterred, she then formed the English School Theatre Movement, concentrating on bringing Shakespeare to the attention of working-class children. Price was awarded a CBE in 1950 for her services to the stage.

Although most known for treading the boards with over thirty productions behind her, she also starred in twenty-six films, a handful of BBC television programmes and published over twenty written works. Nancy made her home in Heather Lane, High Salvington in a house named Arcana (meaning secret or mystery), within sight of Salvington Windmill. She was a keen local rambler and conservationist, actively playing a part in preserving the Downs she loved so dearly, enlisting the help of both Queen Mary and Princess Alice. A wooden bench dedicated to Price remains in an open area at the top of Cote Street to this day. She is also responsible for the war birds memorial in Beach House Park mentioned elsewhere in this book. Nancy died on 31 March 1970. Oddly, we have been unable to find where she is buried.

On a more recent note, the 2015 police drama series *Cuffs* featured multiple shots of the town along with Brighton. The programme has not been commissioned for a second series.

DID YOU KNOW ?

Rivoli Cinema was Worthing's first purpose-built large-capacity cinema, constructed in 1924 at the north end of Chapel Road. The Italian-Renaissance-styled building could seat 1,700 and was built by Carl Seebold, the man behind the Dome on the seafront. Seebold was a bit of a showman who liked to do things differently. The structure was fronted by a large, illuminated gold ball on the rooftop and sported a sliding roof which was opened in summer. A fire in 1960 caused irreparable damage to the rear of the building which was later turned into a car park. The remaining front section was used for many years as an auction house. The structure was demolished in 1984 as part of a road widening scheme. A block of flats on part of the old site is named Rivoli Court in its memory.

Reginald Marsh is another one of those actors whose face you'll remember but probably not the name. Marsh had been a staple of British sitcoms since the 1970s. He was born in London but grew up in Worthing. After leaving school and working in a bank, he was introduced to an agent via an actress friend. He became a regular in *Z Cars* and *Dixon of Dock Green*, as well as appearing in *Coronation Street, Emmerdale Farm, Crown Court, Bless This House, The Good Life,* and *George and Mildred,* to name but a few.

DID YOU KNOW ?

As was the fate of many cinemas, the Plaza Cinema on Rowlands Road evolved into a bingo hall. Worthing had, at its peak, four fully functioning picture houses, of which two remain as such. The Plaza opened in 1933 and was built in an art deco style. Unusually, it also had a ballroom and a fully equipped performance stage along with a Compton organ that rose out of the floor. It ceased showing films in 1968. The original seats in the circle are still there, hidden above a false ceiling.

And the Band Played On

Most seaside resorts have a music venue of one type or another, some grand and others less so. Bands of yesteryear relive their experiences of former glory days to the amused and bemused. Worthing is, of course, no exception. However, in the early days the town played host to a number who would later go on to fame and fortune. There was many an evening in the local pub where the imbibers would recall stories of past concerts and lay claim to having met the artist who grew up or played within the bounds of our town. In order to settle some scores, we have looked into who was where and when.

Keith Emerson of Emerson Lake and Palmer
Emerson's family lived in Worthing but were evacuated to Todmorden, Yorkshire during the war. It was during this departure that Keith was born, so we can blame Hitler for missing out on that one. They returned at the end of the Second World War to a council house on the Maybridge Estate in Goring. Keith showed a growing interest in classical music at an early age, possibly influenced by his father who was a musician. Emerson attended West Tarring School for Boys and later went to work for Lloyds Registrars in Worthing. At lunchtime he would play the piano in local bars. In 1963, at the age of nineteen, he cut his first record under the name of the Keith Emerson Trio; only five copies were pressed by the Cray of Worthing/Sound & Vision Services record label. Sadly, Keith died during the writing of this book.

Billy Idol
William Broad was born in Middlesex in 1955. His stage name was said to be inspired by a schoolteacher's nickname, appropriated due to him being somewhat lazy. He went on to find fame in the punk rock scene during the late '70s in the band Generation X before going on to achieve greater fame and success as a solo artist; he was one of the first stars of

MTV, later accepting a number of film roles. Idol attended Worthing High School for Boys in the early '70s before moving on to the University of Sussex to study English.

Simon Mayo

Clearly not a musician, Mayo is inextricably linked to music as one of the UK's most popular radio DJs. Born in London, Mayo attended Worthing High (known then as Worthing Grammar School) from the age of fourteen. After school he started work at Burtons, the tailor in town, before moving on to council employment. As an employee, his duties included anything from being a paddling pool attendant to sweeping up in multi-storey car parks. Mayo learnt his DJ skills while working for Hospital Radio. He joined BBC Radio 1 in 1986 to present an evening show. Both his parents were local school teachers; his mother specialised in French.

For the Record

Although almost no musical stars were born in Worthing, we've played host to a few in secret. There was a growing trend at the end of the 1960s for recording studios to move out of the overcrowded and overpriced cities and into more relaxing environments – Saturn Sound Studios was one. They set up business on the ground floor of the Central Hotel just opposite the main railway station here in Worthing. It became convenient for the artists to record and stay on-site; producers believed this resulted in better performances and the best use of studio time, and this wasn't cheap.

David Ruffell, the owner, later sold it to Adam Sieff (of the Marks & Spencer group) where it became Pebble Beach Studios and moved from the hotel to Teville Place, with an office in South Farm Road just south of the railway crossing. Today there is no hint of it ever having existed.

Roger Cloake, one-time manager of the studio, recalls that the 'rank and file' were accommodated at the local hotel but 'the luminaries' were put up at one of the town's then three-star hotels: Warnes (now gone), Chatsworth, Berkley and the Beech Hotel (also gone). Roger had the understanding that Thin Lizzy, in the Gary Moore days, rehearsed and stayed at the Central (now the Grand Victoria). We can also confirm three tracks were recorded there in 1976 by The Stranglers. Garry Brooker of Procol Harum played and produced for Be Stiffs' album *Juppanese*.

Alma Cogan

Today Alma Cogan would be up there with the likes of Lady Gaga and Madonna. Cogan was Britain's highest paid singer in the 1960s, earning over £1,000 a week. Although not born in Worthing, she was brought up over the family haberdashery shop in town. Her singing career started when she performed with the band on the pier at tea dances. After winning a competition in Brighton, Dame Vera Lynn prompted her to follow a singing career. Her first record, 'Bell Bottom Blues', sold 100,000 copies. Cogan appeared in two Royal Command performances and was romantically linked with Danny Kaye. Her future was cut short after undergoing stomach surgery, dying shortly after aged thirty-four.

> ## DID YOU KNOW ?
>
> Howarth of London are world-renowned oboe specialists with an outlet in Chilten Street, W1. Few will be aware that this company, formed in 1948, manufacture their instruments here in Worthing. They continue to be the largest oboe producers in the UK, along with saxophones, flutes, clarinets and bassoons.

Lesser Known Public Figures
Funny Girl

Today the name Gladys Morgan raises not one titter, but many of us over the age of fifty would recognise her distinctive Welsh voice. Gladys was born in 1898 and found fame as a comedian, star of variety, radio and later television. From 1958 she called Worthing her home, living at No. 30 Salisbury Road until her death in 1983. Her daughter, Joan Laurie, still resides in the property. On 11 December 2012, Joan unveiled a blue plaque celebrating her mother's life. The ceremony was well attended, organised by the British Music Hall Society and our own Worthing Society. Wyn Calvin and Roy Hudd entertained the crowd with their memories of Gladys before moving on to St Paul's Centre for refreshments.

The Chinaman

This was the name of an antiques dealer in Worthing with a sense of humour. Geoffrey Godden was a world-famous author, historian and lecturer on British ceramics. Born in 1929, he attended Worthing High School for Boys before studying the history of British porcelain, later going on to become a recognised authority on the subject. His business card introduced himself humorously as 'The Chinaman', taking the old term used for a dealer of crockery in the eighteenth century. Godden's books are still used today by experts on the *Antiques Roadshow* where he himself made appearances.

George Forbes

Forbes, washing machine genius, wasn't born in Worthing, but he did die here as a penniless recluse. By rights, he should have been both rich and famous. Although a professor of philosophy, he was best remembered as a supervising engineer for several pioneering hydroelectric schemes, including Niagara Falls. He was admitted to the French Legion of Honour in 1881 for his work with electricity. Forbes had very diverse interests, which included leading a British party observation of the transit of Venus in Hawaii in 1873 and becoming the only British war correspondent with the Russian army in the Russo-Turkish War of 1877, reporting for *The Times*. He received the Russian Order of St George for this work. You are probably wondering what the washing machine connection was: while working for the British Electric Light Company, he experimented with using blocks of carbon for brushes on electric motors (fast-wearing wire or gauze was previously used), thus revolutionising their efficiency and life. He patented his idea under the title 'Improved Means for Establishing Electric Connection between Surfaces

in Relative Motion Applicable to the Collectors of Dynamo Machines'. Forbes sold the American patent rights to Westinghouse Electric for a mere £2,000. Remaining unmarried, he became a recluse, bitterly disappointed that his discoveries and inventions had earned him no fame or fortune. On the advice of friends, he moved down to Worthing where they could care for him. He died in an accident at his home on 22 October 1936.

Hugh Lloyd

One of those comfortable, familiar faces gracing our television screens from the 1960s to the '80s, Lloyd's demeanour nearly always suggested he would be the underdog, the silent hero, or downtrodden victim of a comedic setup – a springboard for others to bounce off. He is most often remembered for a bit part in Tony Hancock's famous 'The Blood Donor' episode. In spite of this small recognition, he was a successful actor in his own right with his own television shows such as *Lollipop Loves Mr Mole* and *Hugh and I*, in which he co-starred with Terry Scott. Lloyd appeared in around nineteen films and had many parts in television plays by famous authors such as Alan Bennett. His last small-screen appearance was in an episode of *Doc Martin* in 2005. Hugh Lloyd moved down to Worthing in 2003 with his fourth wife, Shan Lloyd, a Fleet Street journalist. They lived in Dolphin Lodge at the bottom of Grand Avenue. Hugh died in 2008, followed six months later by Shan.

John Henry Pull

Pull was a member, and later president, of the Worthing Archaeological Society, where he is well remembered for his excavations of the prehistoric flint mine at Cissbury Ring on the South Downs in 1947. Although not a professional archaeologist, he was responsible for finding many of the important Neolithic sites in southern Britain. Because of his non-professional status (he was a postman by trade), much of his work wasn't recognised by a number of experts. Forty years after his death, *Time Team* excavated one of his discoveries and confirmed that his work was indeed valid. Pull died on 10 November 1960 while having just begun a new job as a security guard at a recently opened branch of Lloyds Bank in Durrington, the victim of a shotgun blast fired during a robbery there. Much of John Pull's work is held in Worthing Museum.

Lennard Barber

Barber was literally instrumental in pioneering the ability for modern aircraft to land blind. Born in Finchley in 1921, he moved down to the south coast in 1928 into a house situated in Wallace Avenue, which was built by his father Charles Barber (a builder by trade). Barber attended Worthing High School and in 1935 moved on to Brighton Technical College. He was directly recruited by the RAF and employed in the testing and problem-solving of electronic equipment in the newly developed field of radar. Both airfields and aircraft carried radar and radio transmitters but it was Barber, using his own patented 'Barber's Box', that allowed the two separate systems to 'talk' to each other, so to speak. This resulted in what is known today in the trade as ILS (Instrument Landing System), allowing aircraft to land in low or zero visibility. After the Second World War, Barber returned to Worthing and set up a company called Pinta which specialised in small ship and boat navigation systems. Barber died in 2013 with few realising just how important he was to so many.

DID YOU KNOW ?

The Connaught Theatre was the venue for Terence Rattigan's play *Variation on a Theme* (1958) starring Sarah Churchill, daughter of the former Prime Minister, Sir Winston Churchill. He and Lady Churchill attended one of the performances.

John Bowers

A well-known name in the music industry, but one most people likely won't recognise, Bowers and his lifelong friend, Peter Haywood, set up a company in Worthing in 1966 called B&W Electronics. They made speakers by hand in the back of an electrical shop they ran in an area just north of West Tarring called Thomas A Becket. One of their customers, so impressed with the quality of the sound produced by their speakers, left them £10,000 in her will to develop the business. Needless to say they succeeded, developing a large industrial manufacturing works in Worthing and Bradford. B&W speakers and headphones are now much desired both in the music industry and at home. The original shop at No. 1 Becket Buildings, Littlehampton Road, is still there under the name of Bowers & Wilkins, selling high-end audio equipment.

Peter Bonetti

Peter is a former England and Chelsea goalkeeper, born in London in 1941. His parents, Joe and Lydia, moved down to Worthing in 1948 and operated a hotel before opening the Rendezvous Café on the seafront next to the Dome Cinema. Bonetti's football career began in the 1950s when he played for Worthing Catholics alongside his three brothers. Some may recall from his Chelsea heyday the trademark ability to throw a ball one-handed as far as anyone else could kick it. He still has relatives in Worthing and is a regular visitor, occasionally sitting on the seafront bench opposite his parent's old café, where there is a plaque dedicated to their memory.

Frederick George Miles

Miles was a British aircraft designer, born in Worthing in March 1903. By the age of nineteen, he and his brother George had built their first light aircraft called *The Gnat*. This became the foundation stone for the Gnat Aeroplane Co., an aircraft training school. Success in various aviation fields, including the military, led to the formation of Miles Aircraft Ltd in 1943. In the same year, Miles was also involved in the manufacture of Laszlo Biro's now well-known and revolutionary ballpoint pen. Miles's aircraft used ball bearings from disabled Spitfires in the manufacture. They became extremely popular due to the ability to write at high altitude in unpressurised aircraft crew compartments. Miles died in 1976 in Worthing. Oddly enough, he insisted on being addressed only by his surname, even at home.

Jamie Hewlett

Hewlett is a Horsham-bred artist who lived in Worthing while attending Northbrook College. In the late 1980s he created a cartoon strip called 'Tank Girl', along with his friend

Alan Martin, which featured in a magazine called *Deadline* and achieved a cult following. The publishing company Penguin purchased the rights to collate the individual strips into a book which was sold worldwide. The year 1995 saw Hewlett's creation made into a film by Stephen Spielberg. Unfortunately, it wasn't one of his better ones and flopped at the box office. Hewlett later opened a fashion shop in Worthing called 49; it too was unsuccessful and closed shortly afterwards. Having now moved to London, he ended up living with Damon Albarn from Blur. These two distinctive characters created a comic-strip band called Gorillaz who went on to win two MTV Music Awards for Best Song and Best Dance Track. Many might not have realised that Hewlett was also responsible for the decoration in one of our nightclubs in his early days in Worthing – it was known as The Factory, in Chatsworth Road. The decor included a Ford Escort hanging from the ceiling, red and green stripes, with one wall covered in 1970s wallpaper, overlaid with blown-up panels from the comic strip. On the toilet walls, pages from old comic book annuals could be found. The club later became Liquid Lounge and is now the One Club. Sadly, all traces of Hewlett have since gone.

DID YOU KNOW ?

Angela Barnwell, Worthing's only Olympic hopeful, aged just sixteen, was a finalist in the 1952 women's 100 metre freestyle held in Helsinki, Finland. She finished fifth and eighth in two disciplines. On her return home to Worthing in August, she was welcomed by a crowd numbering some 5,000 on the steps of the town hall ahead of a civic reception in her honour. Angela just missed out competing in the 1954 Empire Games in Canada by a fraction of a second. She lived in Orchard Avenue, West Tarring. Sadly, she died aged just twenty-nine after a long illness.

There Is a Light That Never Goes Out

As with many modern things, aesthetics is overruled by functionality. Recently in Worthing a street-lamp replacement program has taken place. This has largely rid the town of the old fashioned concrete and metal street lighting, replacing it with modern structures providing greater efficiency and lower light pollution.

Street lighting is, of course, an urban necessity, but it wasn't until the Victorian era that it became viable with the advent of gas lamps. By the end of the nineteenth century, Worthing had over 500 gas-powered street lamps. Over the years, replacement of these has caused stirrings among local conservationists. In 1901, the borough council took the decision to replace many of the original lamp standards with new ornate cast-iron arc lights; a total of 110 were installed, but only one remains.

The old lamp post in Farncombe Road.

Situated on a small floral roundabout between Farncombe Road and Church Walk, east of the town centre, this lone survivor was saved from demolition by local campaigner Pat Baring. Following a lengthy battle, in 1975 the lamp post received a Grade II listing. Pat Baring was a formidable woman, once described as 'a vociferous old battle-axe', a title she revelled in. It is thanks to her sit-in protest that this lamp post, Beach House, and other buildings in the town remain standing today.

The lamp stands some 20 feet high, with the lantern itself comprising of hexagonal frosted glass panels with supporting brackets in a daffodil design. Unfortunately, it maintains a decorative purpose only and has once again become the target of concern, standing as it does on what is, at times, a very busy junction. Thankfully, in these more enlightened days, what remains of the town's heritage enjoys some protection. The lamp did not form part of the town's replacement program and is currently under the protective auspices of the county council.

Recent pressure, no doubt inspired by Pat Baring, placed on local authorities from conservation groups in other areas of the town, such as Western Row, has resulted in the decision to replace other Victorian street lighting being overturned.

For Whom the Bell Tolls

Has anyone seen the 'Barracks' in Chapel Road? This was the name given to the 'new' town hall after it opened on 22 May 1933. Some thought the building was stark and severe with a military feel about it. The adopted moniker wasn't intended to be complimentary, it was more of a comment of disapproval.

Costing £120,000 to build, which in itself attracted nods of discontent, this bastion of civic pride replaced Worthing's first town hall, situated roughly where the steps are leading up to the Guildbourne Centre in South Street. We are sure that most reading this will be familiar with the original building, as photos are commonplace on the internet and in local history books.

The first town hall was opened in 1835, thirty-two years after Worthing achieved official town status. In these intervening years, civic meetings were held by the appointed town commissioners in various hostelries around the town, most notably the Nelson Hotel in South Street and the Royal George in Market Street. Here they would discuss issues such as installing street lighting, adequate sanitation measures and water services. It eventually became illegal for local boards to meet on licensed premises, but one must presume that these meetings were not tainted by the intake of alcohol as these commissioners made a great fist of improving the town; unlike the planning departments of post-war Worthing, whose wanton destruction of the town's heritage leads one to wonder if they were sometimes under the influence when making such disastrous decisions, the public outcry can still be heard today.

The town hall bell under the stairs.

With the opening of the new town hall, the old building, although no longer the centre of municipal machinations, continued to be used for meetings and storage. The bell tower became unsafe and was removed shortly after the Second World War, until eventually, in 1966, the building was demolished entirely. Not all remnants of the building were lost, however. The building that replaced the town hall, the much maligned Guildbourne Centre, is home to an often overlooked reminder of the past. Hanging semi-hidden inside the centre, just under the now disused staircase, is the old town hall bell.

The bell is no longer in the best condition, bearing a few scars from its previous life. Writing just below the shoulder details the maker as 'Thomas Mears of London, founder 1834.' One would think that this could have been appropriated for the new building but at present it hangs silent, missing its clapper and chipped around the rim, a few feet from its original home – a nice feature in a rather bland setting for those who care to notice.

The Miller's Tomb

On top of Highdown Hill stands the final resting place of one John Oliver, formerly a miller by trade. It sits isolated on Highdown Hill, his coffin having been carried by bearers

The Miller's Tomb, overlooking the coast.

dressed in white followed by young maidens in similar attire. Together they paraded around the field in front of a gathered audience of approximately 2,000 mourners before finally coming to rest at the waiting tomb, where a young girl said to be no more than twelve years of age read the sermon.

The year was 1794 and Oliver had reached the enviable age of eighty-four years. What deed could he have done to be honoured in such a fashion? Was he famous? Was he rich? Not really; he was just a simple miller living on a hill. Fortunately, we have an account of John Oliver written in 1805 by John Evans on his travels around Sussex. Much has been written since as local folklore, but omissions, errors and, to some extent, exaggerations tend to creep in.

As Evans approached the tomb recommended for inspection by a friend, his earlier expectations were that of a plain stone with little more than a basic inscription on top. The reality was somewhat different. The tomb, a classic tabletop design usually only afforded to the wealthier classes, was surrounded by tall iron railings. It was brick built with a solid stone top inscribed with the words, 'For the reception of the body of John Oliver, when deceased, to the will of God; granted by William Westbrook Richardson, Esq. 1766.' One side of the tomb contains the inscription:

> Why start you at the skeleton?
> 'Tis your own picture that you shun;
> Alive it did resemble thee,
> And thou when dead like that shall be

This must have been the cause of some confusion for Mr Evans; the phrase 'when deceased' would seem to be out of place. To add to this, at one end of the tomb is the carved legend, 'In memory of John Oliver, Miller, who departed this life, the 22nd of April 1793, aged 84 years.'

The answer thankfully became self-explanatory when it was revealed that the tomb had been built in 1766, some twenty-seven years before Oliver died. This wasn't the only example of the miller's forethought, for under his bed he kept a coffin in readiness, and it is said that, with his leaning towards mechanical contrivances, a device had been constructed where by pressing a lever or spring, the coffin, which had been fitted with casters, would eject itself from under the bed on command. His talent for amusement also manifested itself with two roof-mounted weather cocks. One was in the form of a miller filling a sack of flour with a shovel, the other represented a custom house officer wielding a sword in pursuit of a smuggler, who in turn was being beaten by an old woman with a broom. Both of these were cleverly designed to be animated by the wind, bringing much joy to onlookers. It is the later smuggling connection that is most associated with John Oliver, which we shall discover shortly. To add to this eccentricity, there was a wooden cabin-like structure built behind the tomb from which, when the two front doors were opened, a magnificent view of the south coast could be admired. The internal walls of the cabin and doors were inscribed with passages from the Bible and a poem from the hand of the miller himself.

The task of keeping the tomb in good repair fell to his daughter, Owena, as well as keeping the legends inscribed upon it intact in order to inherit her share of the estate.

Born in 1709, John Oliver was, the son of Clement Oliver, also a miller. Highdown had been the location of a windmill since the fourteenth century, being ideally placed atop the hill to catch the coastal winds. It also afforded an unprecedented view of the south coast from Chichester to the west and Brighton to the east. It was this position that is said to have been used to its advantage by local smugglers.

Smuggling was rife along the south coast. These days there is a romantic view taken of the activity but its practice was solely for the illegal importation of alcoholic spirits, wine and heavily taxed items such as tobacco from France, along with silks and spices. Trading in illegal contraband, however, was a two-way street; smugglers were also in the export trade, wool being one of the earliest commodities used in illicit dealings. Not only was it an offence to avoid paying the required levy on import and export, as it still is today, it was also an unhealthy practice. The men, often local fishermen, would have to run the gauntlet of the custom officers, known at the time as the Preventative Men. There was a genuine risk of being shot or, if caught, hanged, dependant on the value of the goods they were caught with.

In order to gain the advantage it is said that Oliver, given his commanding view of the seascape, would set his windmill sails in such a fashion that would indicate safe or compromised passage ashore: if the coast was clear, the sails were set in the fashion of a St George's cross; if government officials or the military were about, the sails were set in the form of the cross of St Andrew. There are also claims that his pre-built tomb and coffin under his bed, which would disappear into the floor at the pull of a lever, acted as suitable short-term hiding places for the smuggled goods, reasoning that these would on inspection, remain respectfully untampered with.

Although these ideas may seem a little fanciful, history does recall that these tricks were indeed employed along the coast. St Andrew's Church, in the nearby village of West Tarring, is recorded as one such hiding place. A sunken box in the churchyard was graced with a sturdy lid; the top was turfed, making the ideal concealment and one that the excise men would be least likely to look for given its placement.

Today, anyone can take the time to enjoy the view afforded from the Miller's Tomb, which still remains in reasonable condition after its restoration a few years ago. However, the words are less legible now due to wind and natural corrosion.

Many rumours surround the plot, one being that Oliver was buried face down because when holy judgement came and the world was turned upside down in a new beginning, he would be facing the right way. During restoration work on the tomb, the opportunity was taken to dig down to discover the truth; Oliver was found to be buried in the customary face-up position. Another tale tells that running around the tomb seven times will summon the devil, which is common Sussex folklore designed to prevent anyone being too inquisitive (the trick is also employed by smugglers). A similar story surrounds the nearby Chanctonbury Ring.

It is worth reiterating that some 2,000 people attended Oliver's funeral in 1793, such was his renown. Given that the population of the surrounding villages would only have numbered a few hundred each, this is a remarkable figure. Whether this was a measure of the quality of the flour he produced or recognition of other services he supplied is anyone's guess.

After his death, many people would make the journey up the hill to see the tomb. Oliver's daughter, perhaps inheriting her father's ability to see an opportunity to make money, would sell refreshments to visitors from a small wooden cabin built alongside her father's place of rest.

The windmill has long since gone, along with the wooden cabin and John Oliver's home. The site stands a little north of Highdown Gardens on the Littlehampton Road (A259).

RAF Durrington

Yes, there actually was an RAF Durrington, but we're sorry to disappoint you: it wasn't an airfield, it was a radar station. Built in 1941 in Palatine Road, it was one of six ground-controlled interception (GCI) radar stations constructed in coastal areas to track and report enemy aircraft. The windowless buildings remained until around 1954, at which time they were converted into the school building there today, forming the Selden County Junior and Infant School, later becoming the George Pringle School.

At the time, the only other buildings nearby were the ruins of a farm. Walking north would take you across open fields to the main Littlehampton Road and the nearby North Star pub. The school has since been rebuilt and renamed Palatine Primary School, with no trace of the original radar station remaining.

Prior to the installation and becoming a permanent structure, a mobile station, also called RAF Durrington, was in operation. Flight Sergeant Alan Bailes recalls:

> …we were posted to RAF Durrington, West Worthing, a top secret establishment which became the first mobile radar station in the world located on a road of a housing estate as yet unbuilt and surrounded by festoons of barbed wire were a group of camouflaged caravans: generator, AI transmitter and receiver, operations room, VHF crystal controlled R/T van and Admin' guarded by the Black Watch. The unit was not yet operational; our job was to operate the VHF.R/T, our call sign was boffin.

Wilde about Oscar

Yes, that Oscar Wilde, the playwright chap. Wilde stayed at The Haven, a boarding house on the junction of Brighton Road and The Esplanade, from August through to September 1894. He had recently described London as 'becoming intolerable' and took advantage of Worthing's sea air along with his wife, Constance, and their two sons, Cyril and Vyvyan. They had holidayed here the previous year and found the resort favourable.

It was during his time at The Haven that he wrote the majority of one of his most famous and well-received plays, *The Importance of Being Ernest*. At the time of writing, it bore the working title *Lady Lancing*. An original copy of the manuscript currently held in the British library is marked 'The Haven, 5 The Esplanade, Worthing', in case of loss. It has always been assumed that the main character Jack (Ernest) Worthing was named in the town's honour.

Wilde, a flamboyant and respected character, used to regularly walk the promenade and bathe in the waters. At the annual regatta, he was asked to present the prizes for the best dressed water craft, which he did cheerfully, and was noted as saying that the town had beautiful surroundings, an excellent water supply and plenty of opportunities for pleasure.

Wilde and his long-time friend, Lord Alfred Douglas, met in Worthing during the summer. One time, they hired a small sailing boat to take out onto the water for recreation. Two young men, Alphonse Conway (aged sixteen) and a young boy known just as Stephen, were only too pleased to help the pair drag the boat down the foreshore to the waterline; Wilde invited them to join him and Douglas on their outing, which then became a recurrent event. Wilde's marital relationship with Constance had long since ceased and he had embarked on a series of brief relationships with men.

As we know from history, Wilde tried to sue Douglas's father, the Marquess of Queensbury, for libel. It would turn out to be his undoing, as he was eventually arrested in 1895 and charged with committing sexual offences with various young men. Wilde served two years in Reading gaol.

The Haven, later renamed the Esplanade Hotel, was demolished in 1974 and replaced with an office block and petrol station known as Esplanade Court. Antony Edmonds, author of *Oscar Wilde's Scandalous Summer* and a member of the Oscar Wilde Society, discovered that a commemorative blue plaque had been placed in the wrong position on the building. After research, its rightful place has been uncovered; moves are afoot to have it repositioned, but this could be in jeopardy as the winds of change have turned public opinion against Wilde's homosexuality. The town remains undecided as to whether it should admit to entertaining the man.

Time for a Swift One

Half Brick is not a name that inspires the imagination, but one that confuses it instead. It had always been assumed that the Half Brick pub had been built of half bricks. Not far from its current resting place was an area known as Brickfields. The name refers to the nature of the soil or, more importantly, the clay beneath it. Here the clay was moulded and fired into building bricks and it was thought that the pub may have been built using the broken or rejected examples, but this is now thought to be unlikely.

The pub, or beerhouse, was first constructed on the foreshore at a time when the tide didn't reach as high as it does today. This wasn't unusual – the coastline was dotted with

clusters of fishermen's huts as their work was dictated by the tides, night or day. In fact the foreshore was so broad that it was called Worthing Common or Saltgrass, where fairs, events and even horse racing took place. It would be quite natural for one of these huts, perhaps owned by a retired fisherman, to sell beer as sustenance to the men as they waited and repaired their nets.

A great storm was to befall the town which brought along a tidal surge, destroying the simple structures like matchwood. Resilient, the men rebuilt. We like to think that the owner of the beer hut had the idea to construct the base and bottom half of the structure with bricks strong enough to withstand any new onslaught, while the rest was made of cheaper wood, hence the name Half Brick – used in the same sense as one might say half-timbered. Sadly this was to no avail, a further storm was to follow with the same disastrous results. Wisely, the next reconstruction was built more sensibly further inland. It has been noted that on occasions bricks smoothed and rounded by the sea still turn up among the pebbles even now. The Half Brick's final demise came when it was turned into apartments.

So what would be the oldest pub in town we hear you ask? The answer depends on whether you view Worthing as a town or borough. The oldest existing pub in the town is what is now The Corner House; previous names have been The Stage, and the Jack Horner. Originally though, it was called the Anchor, and possibly for a short while, the Golden Anchor – unsurprisingly, located in the old village. The existing building is a 1895 rebuild with the original dating back to at least 1805, which was a much larger structure with grounds that included stables and a pleasure ground that hosted archery and had a bowling green.

Digging through records shows that it was occasionally used as a morgue, as was often the custom during the nineteenth century – many pub cellars were cool and had thick insulating walls (The Bull in Goring is another example). The Anchor though, does not possess a cellar. Perhaps the most notable earthly remains to be held at the Anchor were those of the smuggler William Cowerson. Killed while trying to escape from local officials, a coroner's inquest was held there in 1832.

So, moving on to the oldest existing pub in the borough: first prize here has to be awarded to the George & Dragon in Tarring, dating to at least 1605.

The Egremont, on the junction of Brighton Road and Warwick Road, close to Beach House Park, has recently been refurbished with its lower exterior having been faithfully restored to how it would have once looked. Along the east face of the building, you can't help but notice the tall brick tower, which is currently comprised of apartments. This rear section was once a brewery; atop the tower itself you can see the old metal water tank and, within the brickwork below, arches can still be seen where barrels once rolled in and out.

The Nelson Inn is no more, but evidence of its darker side still remains hidden in a passageway to the left of a popular fried chicken outlet. This is Nelson's Passage, along which several bricked-up windows and a doorway can still be seen. Its frontage, in South Street, showed its more respectable side, but like many of these older establishments, they had a separate bar or room at the back, known commonly as 'Shades'. As public houses and inns evolved, they began to lean towards the wealthier, better-attired clientele. Owners were aware that alienating their regulars wasn't in their financial interest, so this divide was

the obvious solution – separating the 'haves' from the 'have nots.' The Shades catered for the working classes, fishermen, traders and the like; true spit and sawdust establishments where one could, should the desire arise, gamble, get drunk and find a lady of low morals – in essence, prostitutes.

Banksy was Here

On 10 December 2010, the unmistakable trademark stencilling of graffiti artist, Banksy, appeared out of nowhere – even *The Telegraph* newspaper reported it as such.

The creator, famed for his satirical street art, has a huge following and his graphic statements are much sought-after masterpieces, changing hands for thousands of pounds. It is not unknown for art auctioneers to sell these items in situ, leaving the purchaser with the problem of removing them.

Although never proved to be the work of the artist himself, the image was quickly painted over before later being totally erased. Perhaps the council realised that any attempt to remove it could prove catastrophic, especially as it adorned a supporting column of the Broadwater Bridge.

Banksy graffiti perhaps?

Boyes' Folly

Hidden behind houses at the junction of South Street and Westland Avenue in West Tarring, stands a mysterious cobble-faced crenellated tower, appearing to serve no practical purpose. Built around 1896, it stands over 30 feet high and is in a visible state of decline.

A folly, defined in the dictionary as 'a costly ornamental building with no practical purpose, especially a tower or mock-gothic ruin,' was commissioned by William Osbourne Boyes, a local solicitor. Although it falls clearly into the description of a folly, it wasn't one used for showing off, being tucked behind existing buildings at the time of its construction. It is generally thought that William built the structure as a private retreat from his wife and daughters, a peaceful place where he could read, write and watch the sun set. The south side has three arched windows, taking full advantage of the southerly aspect, while the north face has a view of the South Downs.

Detailed study of the folly has proved difficult as it rests on private property. However, an earlier survey showed that there is a slight difference in the external building materials between the ground floor and the rest of the building, suggesting that its construction was in two phases. Apparently, there are steps outside leading down to a basement, thought to be the only way in. From here, a dilapidated spiral staircase twisted upward but unfortunately the subsequent wooden floors have long since rotted away.

The garden of the adjoining property was an open-air tea room for a time, which must have encouraged much conversation regarding this impressive tower – perhaps even questioning the sanity of the man who built it.

Boyes' Folly in West Tarring.

Heads Up

One thing of note about Worthing is the large number of disembodied stone heads dotted about.

Park Crescent, at the junction of Richmond Road and Clifton Road, is blessed with what is known as a triumphal arch, a splendid monumental entranceway to the crescent itself. The main central arch is designed for horse-drawn carriages and the smaller ones flanking for pedestrians. Each arch has four heads, making sixteen in total. Notably, those at the main arch are all larger bearded males while the others are smaller and female. These particular busts are unique because unlike traditional sculptures, these were cast in imitation stone. Up until the time these heads came into being, cast stone was primitive and subject to erosion. Eleanor Coade, of the Coade Stone Factory in Lambeth, perfected a special clay formula and moulding process which, when fired twice, produced an extremely durable, weather resistant artificial stone ceramic. Other examples of her work can be found at Buckingham Palace, Windsor Castle and the Brighton Pavilion.

Liverpool Gardens, named after Lord Liverpool, Britain's longest serving Prime Minister (1812–1827), is situated between Liverpool Terrace and Alexander Terrace and is an open space with mature trees and a pleasant outlook. It is also home to the Desert Quartet. Designed by Dame Elisabeth Frink and unveiled on 13 June 1990, these sombre-faced bronze cast heads measure some 4 feet in height and are set on 7 foot pedestals. The inspiration and name derives from her visit to Tunisia. Like Marmite, some people love them and others, not so much. Plans were afoot to replace them but local and national protest prevented such and so they became a national monument, and worth around

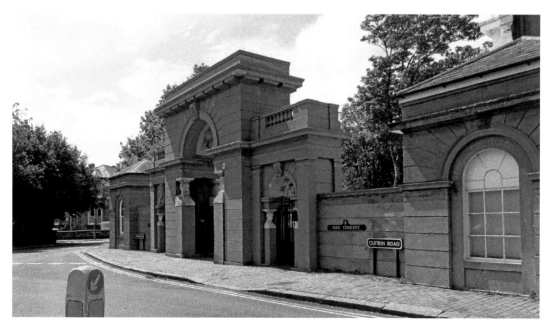

The entrance to Park Crescent.

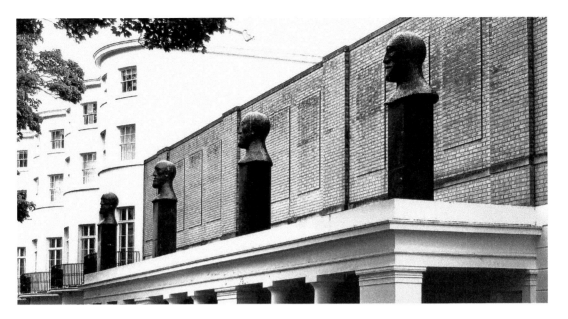

The Desert Quartet Liverpool Terrance.

£2 million. One suggestion was that they should be moved to the low tide mark on the beach, allowing them to be revealed and hidden with the ebb and flow.

It is interesting to note that these 'Frink Heads', as they are known locally, were not the first offering put forward by the sculptor. A frieze depicting a horse, a dog, and a running man was rejected by the council on the grounds of it being unacceptably distasteful – the running man was naked. It has been remarked that the dour-looking heads were Dame Elizabeth's response as a measure of her opinion regarding those that rejected the initial design. Tucked around the north corner of the same building are yet another four heads which are almost identical to those at Park Crescent.

The Eardley, on Marine Parade, is a well-designed attractive apartment block which replaced the old Eardley Hotel after a disastrous fire. Built in a style that is complimentary to Worthing and its Edwardian/Victorian heritage, the last thing you would expect to discover are faces hidden among the architecture. During its construction, an auction was held and three winners would have their faces immortalised as grotesques, similar to gargoyles but without the water spout; £10,000 was raised for local charities at the event. A total of five faces appear, three of which were the Worthing winners whose identity has been kept a closely guarded secret. To spot the faces on the southern side of the building you will need to examine the decorative features just below the roof line.

Often overlooked are the stylised fish heads seen in the image here, which are found at the foot of iron poles holding up some of the older seafront shelters. Rather than just being a decorative feature they are functional too: each one is really a drainpipe, a sort of ground-based gargoyle if you like.

A gargoyle drainpipe.

Got a Lot of Bottle

Sitting on the western side of the northern half of Grafton Road, lies a large house known for many years as the Devonshire Dairy.

Every now and then historical research will throw up an anomaly. The writing over the porch of this property proudly announces that it was built in 1836. Written records, however, state that this structure was first recorded as a dairy in 1842 under the ownership

The old Devonshire Dairy.

of Mr G. H. Piper, eventually passing into the hands of a Mr H. Harbord. It is quite possible, of course, for this to be the case – it could have been a dwelling for a number of years before it became a dairy. Additionally, records have often proved to be wrong, or wrong dates have been mistakenly attributed. More curious though, is the complete absence of the dairy on a town centre map from 1848. It is difficult to believe that a building of such importance and public reliance would have been omitted, especially as the map would have been a professionally produced work. However, the dairy does appear on a tithe map from 1852 – perhaps we will never know the truth.

There is one other unusual aspect. Standing in the street, casually observing the well-maintained and attractive building, one can't help but notice that it seems to be at odds with those around it, particularly regarding the direction in which it faces. Originally it would have stood there alone and surrounded by fields, possibly once used as grazing for the very beasts that supplied its livelihood, but as the town's population grew and civic planners got to work laying out streets in an organised fashion, surrounding houses were built along lines following a predominantly linear direction with the roads running in the more acceptable east–west and north–south orientation. This then begs the question, is the dairy out of kilter with the surrounding houses or are they out with the dairy?

Pasture farms from throughout the local area would bring their produce to the dairy on a daily basis, which in its day was famous not just for its pure Jersey milk and butter, but also for Devonshire Junkets (a dessert of sweet flavoured milk set with rennet not dissimilar to panna cotta today), cream, cream cheese, clotted cream and eggs; sending out supplies '...three times daily to insure prompt and punctual delivery in every quarter'. The building was converted into two flats a number of years ago.

The dairy in older times.

Make Mine a Double

Meyrick Edward Clifton James died at his home in Thorn Road, Worthing in May 1963. Today his name would ring no bells, but once upon a time he was one of Britain's best-kept secrets.

An Australian born citizen, M. E. James was an actor by profession, though by all accounts not a memorable one. As the Second World War approached, he signed up with the British Army as an entertainer, hoping to be attached to the ENSA (Entertainments National Service Association). He was, however, overlooked and ended up serving his time as a Second Lieutenant in the Royal Army Pay Corps, based in Leicester. Fortunately for him – and perhaps less so for them – the Pay Corps had their own drama group. It was here that someone spotted his real talent after he performed an impersonation of Bernard Montgomery, or Monty as he was better known, Commander of the British 8th Army and later Field Marshal.

It probably wasn't his acting ability as much as his looks – at a distance he appeared almost identical with his thin face and moustache – that attracted the attention of clandestine departments. A few weeks before D-Day, he was approached by MI5 to perform what would be the greatest performance of his life, he was to impersonate Monty himself – he just didn't know it yet.

Called up to London on the pretence of making a promotional film for the army, he was met by Lt-Col. David Niven (the film star), who worked for the film unit. From here, James was assigned to Montgomery's staff to study his voice and mannerisms. The two men couldn't have been more different, Monty didn't drink or smoke and so James, presumably much to his chagrin, had to give up both to be convincing, even when supposedly out of view. There was also the issue of a small, but noticeable, physical problem: James had lost a finger in the First World War, therefore a false one had to be made to keep the pretence alive.

His duty was initially simply to be seen and with this in mind, he was ferried around Europe, the Mediterranean and Africa to improve morale and give the Germans a false impression of where he was, freeing up the Commander for more important invasion plans. His new-found skills were also put to use at home. He famously appeared on Broadwater Green giving a speech to gathered troops prior to the invasion. No one was any the wiser.

His claim to fame was sadly short lived. He returned unceremoniously back to the Pay Corps five weeks later under a vow of silence. Some say it was his liking for the bottle and a cigarette that had proved too much for him to hide.

James was demobbed in June 1946 and attempted to revitalise his acting career but failed to do so. In 1954 he published a book called *I Was Monty's Double*, recounting his wartime exploits. In 1958, the book would become a film of the same title starring John

Mills and Cecil Parker – James, of course, played both himself and Montgomery. The film largely follows true events, with a little extra Hollywood sparkle added for good measure. It is perhaps pleasing that James would at last receive recognition for his valuable service during the war years. Bernard Montgomery admitted that although he was fully aware of James's existence, he had only ever spoken to the man once.

James was sixty-five when he died. In his later years he could be spotted walking around Worthing and enjoying a drink at the Ship Bar and Grill in South Street.

The Bride of Christ

There is an area north of the town known as Charmandean, a name thought to date back to the 1500s, possibly derived from 'Charming Dean', roughly translated as 'a beautiful view over a valley'. Being set on the south side of a hill, it would have been fitting at the time. Occupied as farmland initially, it would later be graced with a large mansion that would become the home of the strange but generous Mrs Ann Thwaites.

It would be fair to say that Ann Hook was of low birth when she met William Thwaites (Thwaytes), a wealthy grocer and tea merchant of Fenchurch Street, London. Her sister, Sarah Hook, had become resident housekeeper to Mr Thwaites and no doubt

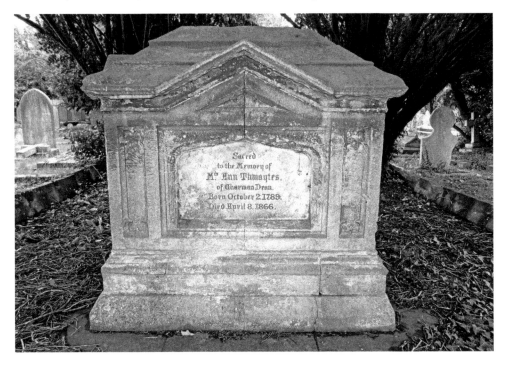

The tomb of Ann Thwaytes.

occasionally employed Ann when the work would allow. In 1816, Sarah married one of the merchant's employees and Ann married William Thwaites. She was twenty-seven and he was seventy. In spite of the glaring age difference, and no doubt the wagging tongues, Ann Thwaites, in true *My Fair Lady* fashion, soon rose to her new station and became socially accepted.

William Thwaites died in December 1833 (registered in January 1834) and made many considerably generous bequests to friends, relations and staff. The balance, some £500,000, went to his wife.

Ann went on to live in Hyde Park Corner, a residence she retained all her life but also purchased property in the much favoured seaside resort of Herne Bay in Kent, where she and friends would stay on a regular basis. She enjoyed the town so much that she became one of its main benefactors, donating £4,000 in 1837 to build a clock tower, believed to be the first free-standing neoclassical structure of its type in the UK. It remains today as a noted focal point. For reasons unknown, Ann fell out of favour with the town, or it with her. She was never to visit again, instead moving to Worthing, where in 1840, she purchased Charman Dean, a (then) modestly sized Georgian house.

Having lived in relative opulence, it was only natural that she would have designs on the property and thus it slowly evolved into an impressive mansion in its own right. First, two new wings were added east and west, while along the front a splendid south facing veranda with a balcony above tied it all together. To the east side, a large conservatory was erected, designed in the style of the Great Exhibition of 1851. The estate had two entrances, both with pillared iron gates which were themselves copies of those found at Buckingham Palace at the time and allegedly shown at the Paris Exhibition of 1855.

Mrs Thwaites wasted no time in contributing to Worthing's wellbeing. She helped the poor by supporting the local coal distribution service that had been set up for that purpose. During the Christmas of 1854, the service failed to function, for reasons unknown, so Mrs Thwaites ensured that over 600 poor families remained warm over the festive period at her own cost. She also contributed to the building of the Worthing Dispensary along with the poet Sir Percy Bysshe Shelley, laying the foundation stone and being presented with a silver-plated trowel marking the occasion, something of which she was beginning to be a collector of.

Ann also had an interest in religion, having built her own chapel within Charmandean, so when restoration work was required on Broadwater Church she was eager to help. Perhaps it was her generosity that allowed her to obtain one of the carved stone window frames removed during repair, later having it placed in her garden as a feature or mock ruin, something the Victorians found a great delight. To put her generosity in context, the £100 she donated towards a new organ for Broadwater Church would be worth over £7,000 today.

What was rarely mentioned were her odd turns, strange moods and religious fervour. At the time it would have been considered impolite to mention such events, let alone note them down. Early in her marriage she had accused William of trying to poison her, but it was later noted that she had 'recovered from her illness'. Sadly, as time passed, these illnesses became more pronounced. We do know that she turned one of the bedrooms in her London Hyde Park home into a reception room for the Saviour, claiming herself to be the bride of Christ.

Her eccentricity in Worthing manifested itself during the appearance of each full moon, when, dressed entirely in white, she would instruct her coach driver to proceed at haste towards the River Adur on the border between Lancing and Shoreham. They would stop here before returning in the direction from which they had come. The driver, the aptly named Mr Friend, would never disclose what took place. It was a secret he took to the grave, as did she.

Ann Thwaites passed away in April 1866 and is buried in a splendid tomb in Broadwater Cemetery within a large tree-bordered plot with space for her sister, nieces and nephews. She remains, to this day, the only occupant.

Charmandean House survived for almost 100 years hence, having four more owners before changes began to appear. Such a large estate would have been a costly expense and in 1926, a large section of land was sold off for housing, creating five roads unimaginatively named First, Second, Third, Fourth and Fifth Avenue. In that same year, the house and remaining 18 acres of grounds became St Michael's Boys' Preparatory School and later Seaford College. By 1936 it was a girls' boarding school and remained as such until 1945. The axe finally fell in 1963 when the house was demolished to make way for around seventy houses in what is still a desirable area of Worthing.

Today, almost nothing remains of the grand house – there's barely a hint that it existed at all. Charmandean Lane, now little more than a rutted track, is the only physical example of the name remaining in use. Noticeably narrower than an ordinary road or drive, it was wide enough for the horse-drawn carriages that originally used it.

In 2013, the last vestige of the estate – a pair of carved stone pillars – were finally demolished. The ornate iron gates that they once supported had disappeared a few years previously, their fate unknown.

Come into the Garden, Maud

If there is one thing Worthing became famous for was its tomatoes, along with grapes, flowers, cucumbers and figs. Okay, that's five, but the point is, this seaside town became one of the largest growers of soft fruit produce in England. Blessed with the high quality soil known as brickearth, a geological feature almost unique to the south coast, it was ideally suited for brick-making, as the name would suggest. It also encourages a rich and fertile soil which the locals used to their advantage.

The advent of glasshouses in the mid-nineteenth century gave this seaside town the leverage others lacked. Prior to this there were just three market gardens, sufficient enough to supply the local townsfolk. Glass was expensive and delicate, but the ability to grow fruit and flowers in abundance outweighed the initial cost. This, in addition to the excellent soil conditions, meant that fruit such as tomatoes (yes, tomatoes are fruit) ripened quickly and, more importantly, before any other in the country. This led to a high demand in London's Covent Garden Market. Fulfilling the need for new season

produce, they were duly shipped via train in vast quantities to the metropolis' markets four times a week, along with flowers and grapes fresh from the vine. Between 1894 and 1895, 920 tons of fruit were sold in London with another 174 tons distributed around the country.

One of Worthing's early pioneers was Dr Cyrus Alexander Elliott, who is said to have constructed the first commercial greenhouse in Ivy Arch Road using large sheet glass from London's Crystal Palace. This dead-end road coincidently takes its name from the Gothic stone and flint arch built in the 1860s at the entrance to his property. Elliott collected the flints from the chalk hills locally with the intension of building a more pleasing scene between him and the town. The arch stood collecting ivy until its demolition in 1967 when it had become unsafe due to neglect. It had been known previously as Elliott's Folly.

At its peak, should they be placed end to end, Worthing had somewhere in the region of 14 miles of under-glass facilities.

Like all good things, this came to an end. By the mid-1940s, cultivation of fruit had been replaced with flowers, quickly becoming the mainstay of the local economy. As the town expanded, however, these market gardens inevitably became pushed further apart and mass production diminished accordingly. Today, anyone setting a fork into the ground within the town's boundary will often turn up shards of greenhouse glass as a reminder of its more fertile past.

Fancy a Coffee?

Before Worthing began to develop into a fashionable seaside resort in the early 1800s, the original old village lay a few hundred yards inland to the north-east, centred on the area occupied by The Swan public house in Little High Street. Back then there was only one road in, the suitably named Worthing Road. This ran from what is now Broadwater Bridge, down Chapel Road, turning left into North Street and then headed south along the present High Street until finally stopping at The Steyne – there was no coast road to Brighton at the time, effectively making the village a dead end.

The post-war years have seen this area destroyed virtually beyond recognition with only a handful of buildings remaining in the High Street of any age and significance. Situated halfway up the High Street on the east side, is a group of four white-faced properties. It is with thanks to three local historians, Barrie Keech, Ron Kerridge and Mike Standing, who together have made a detailed and extensive survey of the old village, that we now know something of their history.

These four houses were all built on a piece of land which was originally a single property in 1690 when it was described as:

a messuage [authors note: a dwelling house with outbuildings] and garden and

The High Street shops.

orchard in Worthing on the east side of Worthing Street [now High Street]. The earliest house on this property later became No. 40 High Street. Part of the garden to the north of this house was subdivided into two small plots of land which were sold off and by circa 1789 two additional houses had been erected facing Worthing Street and later became Nos. 44 & 42 High Street. However, the old orchard to the rear of the property was retained as part of the original property [No. 40]. A fourth house [No. 46] was built around 1870 on the north part of the garden of No. 44 …

Number 40, built around 1690, lays claim to being the oldest survivor in the town. Today, it remains a fine example of a bow-fronted building; the frontage itself is not original but the result of later Georgian remodelling, giving it a deceptively more up-to-date appearance. To many residents of the town, this building will always be known as the Toby Jug Restaurant, a name it operated under for many years. In more recent history it has changed ownership a number of times and been renamed Orchard Café as a nod to its past.

Inside, we can see where the wall has been taken back to the original state, showing the flint and lime mortar mix, along with where more expensive brick had to be used for corners to give the necessary rigidity. It wouldn't be unusual to find wood or stone blocks scavenged from derelict properties incorporated.

The stripped wall in Orchard Café.

Living in a Box

When glancing at this building it is hard to imagine it having any architectural worth. From the front it is nothing remarkable, a simple detached house of no real age and set back from the road.

Named Box Cottage, perhaps the only thing of note is the double-hipped roof. Take a walk round into Little High Street, however, to view the house from the rear and the structure of the building becomes apparent. It is a flint built building dating from approximately 1800. The double-hipped roof is the real giveaway to its age which belies its Victorian frontage. One other building in the town centre shares the same feature: nearby Stanford Cottage in Warwick Street, made famous by Jane Austen who stayed there for a few weeks in 1805.

Box Cottage under repair.

Box Cottage rear-facing flints.

Well I Never

Casting an eye over a town map of a certain age will often reveal a number of small round circles – wells. With no water on tap like today, these often formed the only source for both local and urban populations although standpipes could often be found supplementing the supply. Very few seem to remain, with less still actually being used, if any.

It wasn't just the local community and families that would have had access to a well, some local businesses would also have had their own – one notable example being the New Street Brewery. An accessible source of water would have been crucial for the brewery – any brewery – to be a success and beer was made here from 1832 to the early twentieth century.

One unfortunate story that highlights the importance of these wells is that of the young daughter of one-time New Street Brewery owner George Pacy. During the Worthing typhoid epidemic of 1893, she took ill and died after drinking contaminated water from elsewhere. Although the epidemic claimed almost 200 lives, not all water sources in the town were affected and the brewery well was one that remained free from infection. In fact, drinking beer had for many centuries been thought to be a healthier option than water as the brewing process killed off harmful bacteria. There is a moral there somewhere!

Some wells would have been for public use, and public water pumps would also have existed in the town – one stood near to the old town hall close to the modern Guildbourne Centre, and another at Broadwater Green. We now take piped water for granted. Other

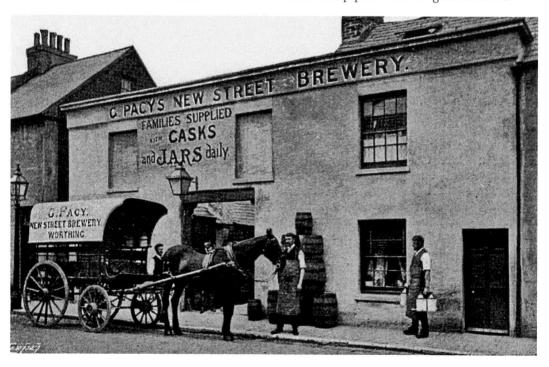

Pacy's Brewery on New Street.

than finding an old well tucked away in a private garden, very little evidence of these public wells, or any other, now exists. One notable exception, however, is the one that served the population of Chapel Fields.

Chapel Fields, found along one of the many twittens that carve through the town centre, was for many years during the nineteenth century the poorest part of Worthing by far.

The path heading north from Shelley Road consisted on the east side of a row of back-to-back houses, only two of which remain to this day (forming part of a newsagent's shop). On the west side and still in situ, is a high flint wall which separated Chapel Fields from the more affluent Victorian villas that housed the wealthier classes.

Walking along there today still gives a flavour of those times and is well worth a stroll. If you continue north along this twitten as it takes a left turn, immediately at this juncture, at the bottom of the small section of north facing flint wall, an unusual feature can be found – a curious bulge.

This is the site of the well formerly used by the residents of Chapel Fields, now sealed up. One can only imagine how clean the water must have been, serving the poorest part of the town with no drainage of any description and open cesspools being the order of the day. Remarkably, this well is recorded as not having been infected in the aforementioned typhoid outbreak. The source of the epidemic was traced to the water tower situated

Fresh Fields sketch (right) and later photograph (left).

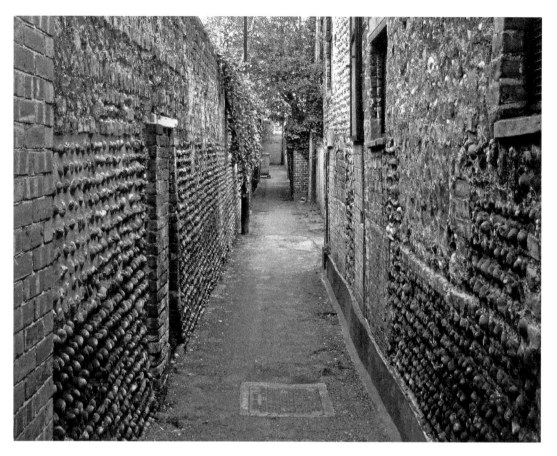

Chapel Fields twitten, leading to the old well.

between modern day Tower Road and Park Road near the hospital – Birch Tree Court now occupies the site.

Another interesting feature is near to the site of the old Cricketer's Arms public house in Marine Parade. Now long gone, and there is no evidence to suggest a pub was ever there, set in the modern paving now covering part of the area, a circular feature can be seen that has all the right dimensions and could very well be hiding an old well. Although this is purely speculation, it is difficult to imagine what else it could be.

Wells that have lain hidden for years will sometimes be rediscovered. Such was the case with one found recently in the garden of the old Castle Inn in Tarring High Street. Uncovered during garden clearance work by former owners, the well was hidden by a gravestone. How this gravestone ended up in the garden of a pub is anyone's guess. As yet, no one has deciphered the memorial engraved on the stone in an effort to trace its origin – an interesting prospect.

Attached to the wall of the house is an old handpump that feeds directly from the well. To our knowledge, neither the well nor the handpump are still in use.

A possible bricked-up well in Marine Place.

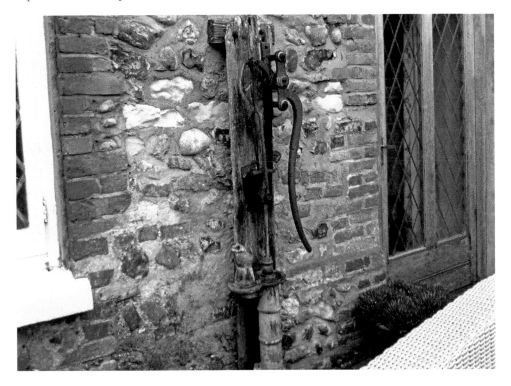

The pump in Tarring.

Pub Memorabilia

Pubs are often renowned for their eclectic collection of memorabilia and those in Worthing are no exception.

The Vine in West Tarring village has a 'last orders' bell hanging behind the bar which is inscribed 'VIC 54 1944'. Research has revealed that it once adorned a small steam-driven supply ship known as a Victualling Inshore Craft. The bell belonged to the fifty-fourth out of ninety-six of the vessels built. These craft were commissioned by the Ministry of Supply during the Second World War to carry varying cargo from munitions to corned beef, and supplied warships at anchor. We are, however, at a loss as to how it ended up here.

The Richard Cobden in Clifton Road is also home to a token of wartime maritime history in the form of a brass porthole with storm cover. It is not overly unusual in itself, but this one has a clock mounted inside. The legend on the clock face reads, 'HMS Loyalty – Harland & Wolff'. *Loyalty* was a minesweeper serving in many locations around Britain during the Second World War, notably taking part in the D-Day landings off Gold Beach. The ship was returning to Portsmouth on 22 August 1944 when she was attacked and sunk by a German U-boat mid-channel and capsized in less than seven minutes. All eighteen lives aboard were lost, along with that of the captain.

The Clifton Arms, also in Clifton Road, had a secret buried in a wall in 1959. The pub was undergoing renovation at the time and the landlord, Frank 'Nobby' Clarke, had an

The VIC bell at the Vine pub in Tarring.

HMS *Loyalty*'s clock.

idea. He was going to hide a time capsule within its structure. On 14 February 1959, 150 of his regulars signed the back of a large scroll – a Charrington's poster, celebrating the company's 200 years of brewing. They also included a second scroll listing the price of everyday commodities such as beer, milk, tea, eggs and so forth.

Paul Holden, editor of the *Worthing Journal*, heard rumour of its existence and when the pub closed in 2010 he, along with James Henry and Colin Walton, asked the builders, who were converting the building to flats, to keep a watchful eye. The package was eventually found in 2011, walled up in the kitchen – the last room to be renovated. It included a copy of the local newspaper telling the story of Frank Clark's idea and is pictured with the scroll and a handful of regulars at the time. Presently it remains in private hands, but details can be seen on a history site dedicated to Worthing pubs at www.worthingpubs.com.

The Dolphin in Dominion Road, or Blue Dolphin as it was originally called, was once used for Roman Catholic services prior to the opening of St Borromeo's in nearby Chesswood Road. The pub is now a supermarket, but the church has a small plaque depicting a blue dolphin in relief, embedded in the wall next to the entrance as a token nod of thanks. Few people would realise why.

The Parsonage restaurant in the High Street, West Tarring has a small and intimate public bar but it isn't one for displaying memorabilia or unrelated mementoes, it doesn't

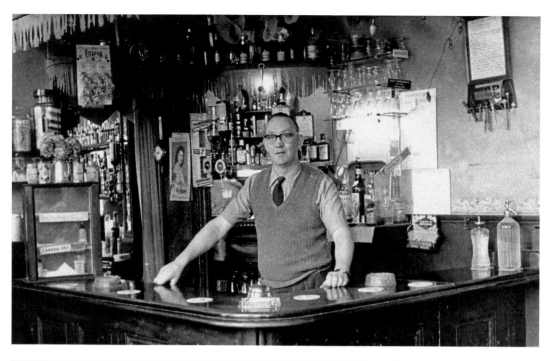

Above: Frank Clark behind the bar of the Clifton.

Left: Time capsule signatures.

The blue dolphin on St Borromeo Church.

need to as the whole building is itself a curio. Built between 1480 and 1500, the present building, distinguished by its jetted first floor which overhangs the street by half a metre, is made up of three cottages. Like the wooden exterior, the inside is made up of substantial oak beams, both on the ceiling and floor – a trip hazard for sure, but thankfully its historic status outweighs current health and safety. Its structure does lead to odd-shaped rooms and floor levels but this only adds to its charm.

Right up Your Alley

Alleys, or twittens, are walled or hedge-lined passageways found hidden in many a Sussex town. As twitten is exclusively a Sussex word, elsewhere in the country these passageways and footpaths are known under various names, often derived from local tradition or influenced by a foreign language.

The word itself is of uncertain origin. One locally accepted derivation is a blend of the words betwixt and between. Perhaps a more logical explanation shows its origins in the Low German word *twiete*, meaning 'alley' or 'lane'. Whichever explanation one chooses to believe, twittens without doubt provide information about the past as the often form old boundaries or ancient pathways.

Shown on the map, from 1875, is part of one such twitten. Originally running north from the old village of Heene until it reaches the upper boundary, now marked by a railway line, it diverts north-west through Tarring village, heading out towards Durrington before turning north again and finally ending at Salvington windmill. Sweeping away modern

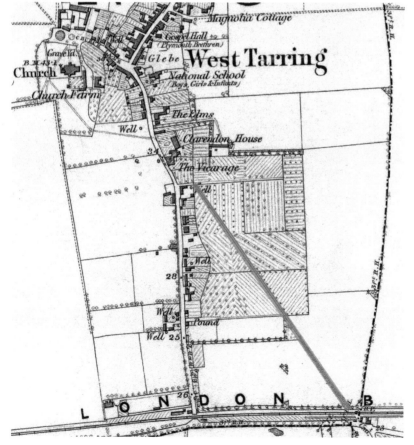

Above: West Worthing twitten.

Left: West Tarring map, 1879.

structures, it is clear to see that these paths denoted the shortest distances between individual villages. As the area developed and land was divided up into smaller plots, few would have dared to cross or inhibit these ancient trackways which goes to explain why they continue to slice through the present landscape. Today much of this is now covered by housing, however a small section of this example still remains (marked in red on the map).

One in particular is famous in Worthing, named the Quashettes. This twitten runs for some distance from the old village of Worthing to Broadwater. Evidence does exist for it extending further still to the old Iron Age hill fort of Cissbury to the extreme north of the town.

Many have long since disappeared, but when looking at a modern map of Worthing one can still find broken sections of this original twitten, part of which still carries the title of the Quashettes situated approximately in the middle of the route.

It has been suggested that the Quashettes connected the old medieval chapel in Worthing to St Mary's Church at Broadwater which once served as Worthing's main church (Worthing at that time came under the jurisdiction of Broadwater Parish) before St Paul's in the town centre opened in 1812.

But why the name Quashettes? An unusual name for a footpath you might think, but it was one that had earned its title. Going back in time, it was known as the Squashettes, and before that, the Squashes. The name is thought to have derived from a marshy area just north of the now submerged Teville Stream in an area known as Ivy Arch. An oil painting of Broadwater by Anthony Fielding in 1848 shows this bog-like area in the foreground. The early version of the name possibly came about by reflecting the sound made underfoot. For reasons unknown the 'S' was dropped and the title extended. An alternative meaning may have derived from fruit having dropped from trees in orchards that once lined part of the route. Whichever is correct, from there it is not hard to see how the name became corrupted into that still used today.

As previously mentioned, Worthing has its fair share of these old passageways, but although many of the buildings in the town centre have been replaced, their modern counterparts have been built around twittens and they remain a prominent feature. A stroll through the town will reveal quite a number and a diversion along them will often reveal historical gems that would otherwise go unnoticed.

What's in a Name

Street names can often hold a secret. Well, not so much a secret, rather a meaning that's been lost to time. Here is the background to some of Worthing's names.

Ten Acres

Situated in Lyndhurst Road in the east of Worthing is a housing estate known as Ten Acres – a name derived from the amount of land it sits on, one would presume. To some extent this is true, but its original name was Poor Ten Acres, not something the residents would find much favour with today, we would imagine. This land belonged to Granado

Chester, then the rector of Broadwater Church. It was rented out for local people to grow food, graze animals and generally put to good use. In his will, he bequeathed the rent gained to be distributed to the poor of the parish. The Worthing poor being what they were, had to fight the temptation to spend this welcome income on beer and spirits – which, of course, they did. The fund managers quickly grew wise to this and instead replaced the money with coal for the winter months. This went on to become common practice with charitable organisations in the area.

Bellview Road

Bellview Road, placed on the western edge of West Tarring village, the name alone doesn't strike anyone as odd. There are hundreds of Belleview's around the country. *Bella*, for example, means 'beauty' in Italian, while *belle* equates to the same in French. So by definition Belleview means, quite literally, beautiful view. It could just as easily have been named Bellavista, the meaning is much the same. What struck us, however, was the spelling of this particular road name, it was wrong – the second 'e' (or alternatively 'a') was missing. It was only when researching the history of the village within the town that the truth was revealed. It's all down to a family that is thought to have invented a peculiar style of church gate.

The family name was Tapsel, residents in West Tarring from around 1561 to 1633. By profession they were bell casters also providing the service of rope-making, having been in business for some 200 years all told. Records show that they cast a bell for the village church, St Andrew's, their bell foundry being within sight, hence the road name Bell View. It is pleasing to know that someone from the council road naming committee had taken time to source a suitable name, even if no one else knew why.

Early maps of the village show a cluster of small, presumably wooden buildings around two ponds just the other side of the church's north wall, thought to be the bell maker's workplace. An adjacent building shows up in the records as the home of Henry Tapsel. Moving on almost 400 years, there is nothing to show for the Tapsel's efforts in the form of structure. Bells cast by the family still exist all over Sussex, most of which are signed by Henry or his son Roger. It is reasonable to assume that unlike today's foundries, the scale was somewhat smaller. The bells themselves were most likely cast within moulds that were sunk in the ground, a common practice at the time. We also have to bear in mind that due to the nature of the work, it would have been a necessity to travel to where they had been commissioned and cast on site.

A Tapsel Gate is perhaps one of the most practicable designs for a churchyard entrance, fitting ideally within a lychgate structure. Resembling a normal wooden five-bar gate, it is unusual in that it pivots in the middle, non unlike a turnstile, thus eliminating the amount of room required to swing open. No one is certain that the Tapsel's invented it, but they do seem to get the credit.

Poulters Lane

Running from Thomas A Becket (West Tarring), directly east to Broadwater, is Poulters Lane. One would be forgiven for thinking the name implied some sort of poultry farm but it couldn't be further from the truth. In 1481 it was noted as Polltree Cross-roads, later in 1875 becoming Poletree Lane. It has also enjoyed the epithets Shady Lane and the equally

romantic, Lovers Walk. It formed an important part of the coaching route connecting Chichester, Arundel, West Tarring (market) and Shoreham Port further east along the coast. This was the reason that Broadwater expanded faster than Worthing, which remained isolated. It has been said that the name Pole Tree may have derived from the type of trees that were prolific in the area, these being straight in growth, making an ideal source for poles and wooden stakes.

Rowlands Road

Known as the East End of Worthing, Rowlands Road joins up the area known as Heene to Worthing town centre. As we've already discovered, today's Worthing is made up of separate villages, linked only by footpaths or rough tracks. The land in-between remained feral and uninhabited. As Worthing grew, so did Heene, however the local Worthing commissioners felt a need to keep the two separate, implying that the residents and farmers of Heene were of a lawless nature. To uphold this, a boundary wall was built. Time passed and the inevitable happened, the areas became one. Rowlands Road is thought to be a corruption of 'rough-lands' – perhaps a derogatory term used for Heene residents at the time, or simply a description of the wasteland between the two villages.

Faggots Walk

Not strictly a road name, but that of a small stretch of promenade east of an area known as Splash Point. In spite of its connotations, not sounding particularly politically correct to us today, we have to bear in mind that this was a time when certain words within our language carried a very different interpretation. In this case, a faggot was the name given to a simple bundle of sticks tied together – what we might know today as kindling – often used to fire up the wood- or coal-burning kitchen range. Larger versions were employed to support river embankments and along coastal paths where erosion was imminent, before more permanent measures were taken (very much as we might use sandbags now). Today, Faggots Walk is known as Beach Parade and sits on the south edge of Beach House on the seafront.

Ophir Road

The name Ophir derives from a biblical port in the Red Sea, famed for its wealth and thus a suitable name for a ship – which it was. Unfortunately, this vessel reached its demise one stormy night in 1896 off the Sussex coast.

Threatening to be dashed against the shore at the neighbouring town of Lancing, so great was the wind and rain that Shoreham Lifeboat was unable to make any headway against the onslaught of the sea. Worthing Lifeboat was launched just east of the pier, having the advantage of being driven towards the stricken vessel by the storm. Using only the available power of sail and oars, the rescue crew were able to approach the *Ophir* and eventually get lifelines aboard, although on several occasions it had to pull away to prevent the swell from crushing it against the ship.

After the storm had settled, the wreck lay strewn on the foreshore, no longer of any use as a seagoing vessel so it was auctioned off, raising the pitiful sum of a mere £34. Ophir

Fisherman's winch from the *Ophir*.

Road in East Worthing was named in its memory. It is still possible to see a small part of the *Ophir* on Worthing seafront. Next to the Beach Office, adjacent to the Lido, stands a fisherman's capstan bearing a plaque with the inscription, 'Used by local fishermen to haul their boats up the shingle beach. It was made from one of the booms reputed to have come from 'The Ophir' which sank off East Worthing in 1896 during a violent storm.'

Molle Soles Lane
Tarring Road is now a busy thoroughfare, linking West Worthing to Worthing Station and a little beyond. It was named after West Tarring, but prior to that the junction of Tarring Road and Heene Road was known as Moll Soles Lane. The only reference we could find for this was in a book called *The Sea-Board and the Down*, written and published by the Revd John Wood Warter, the vicar of West Tarring village in 1860. In this, we came across the text, 'Antony Fairfoot again, never much liked to pass, after midnight, the crossroads where Moll Soles the suicide lay buried.'

Steer's Bank
This was also mentioned in the same printed work by Warter, though the exact position had never been accurately identified. The book quotes, 'Steer's Bank, where another unfortunate was interred before the memory of any man living, was avoided with equal care by Caleb Sooter, within these thirty years. He was neither uninformed nor a coward, but he never returned that way by night.'

Steer, we are led to believe, was a highwayman whose territory included the coaching road between Chichester in the west and Brighton in the east, much of which is now covered by the present A27. We found a story in the *Worthing Herald*, dated 1959, detailing the lives of the Overington family who had lived in Durrington since the 1740s working as blacksmiths. It recalls Edgar Overington supervising some trenching work at Swandean Corner, telling his workers to be on the lookout for human bones as he heard tell of a highwayman being hung at the crossroads, which at the time was the typical punishment for such crimes. Alfred Overington, Edgar's son, when relating the story, confirmed that human bones were indeed found, along with a length of rusted chain. He went on to say, 'Swandean Corner used to be called Steer's Bank, because a man named Steer who robbed a mail coach was hung there, so it must have been his remains that my father found.'

Tower Road

One would think this name would be incredibly obvious to one and all, and once upon a time it was. Linking Park Road and Upper High Street, this road would have afforded you a view of the huge 110-foot brick tower of Worthing's 1853 waterworks. Oddly, it was never in Tower Road itself but closer to Lyndhurst Road, with the main entrance in the High Street. This is another example of naming after what you could see rather than what was there; Birch Tree Court in Park Road is built on the site.

Offington

Tucked away among the modern, almost identical, bungalows in Hall Close, Offington, there is one that stands out from the crowd which dates to the sixteenth century. To the untrained eye it takes on the appearance of a pair of attractive whitewashed cottages with wooden beams and slightly wonky windows, the epitome of a Tudor-style dwelling. It was once, however, a brewhouse for brewing ale. The reason for its seemingly odd location and isolation is a simple one. Originally, this was the home of Offington Hall, a substantial manor house and estate that began life in 1357. Most of it was demolished in the 1960s to make room for housing. Only the brewhouse and a later eighteenth-century addition of riding stables in Hall Avenue remain. The road names are a reminder of what was, but only if you knew its history.

Ethelwulf, Athelstan and Ethelred Road, West Tarring

These are just three roads with unusual names, unless you're a student of early English history. Ethelwulf (Noble Wolf) was the King of Wessex from AD 839–58, territory which included almost the whole of southern England. Athelstan (Noble Stone) was king of the Anglo-Saxons from 924–27, and Ethelred was king of the English from 978–1016. Ethelred is often referred to as 'the Unready'; this wasn't a slight on his character (he was only ten at the time) but instead referred to him being 'ill advised'. Interestingly, these three roads run parallel to each other and are, from the top to the bottom, in the correct date order.

Mechanics' Institute

Today, Montague Street is a mixture of old and new. Much of the older architecture remains only noticed by those caring to glance above the ground floor, as conversion from residences to shops has, in many cases, obliterated virtually all things of note. Dig around a little and a surprise often awaits.

The 1970s were not kind to Montague Street, a number of buildings were lost to featureless commercial development, not least of which was the Congregational Chapel founded in 1804, once standing on the corner of Montague Street and Portland Road, a site now occupied by Boots.

Immediately to the west of Boots lies just another featureless and characterless shop – or is it? Here stood the Mechanics' Institute of the Independent Congregational Chapel, which opened in 1862.

Take a walk down the twitten on the east side of the current building and all becomes a little clearer. Looking at the building from the rear reveals the original back wall of the institute. The ornate neo-Gothic window on display is part of the original fabric of the building, though the glass was replaced fairly recently – thankfully nothing noteworthy was destroyed.

The Mechanics' Institute was originally a place where working men could go as an alternative to the pub; no alcoholic drinks were available, gambling was forbidden, and

The Congregational Chapel and Mechanics' Institute.

The hidden window of the Institute.

games and lectures were laid on as entertainment. The building even operated for a short while as a fleapit cinema. Few residents seem to be aware of this architectural gem.

If You Get My Drift

How many of us, I wonder, have not seen the film *Zulu*? Made in 1964, starring Michael Caine in his first major role, it still makes for good viewing today. Although not entirely factual, it gives a stirring and dramatic insight into the Anglo-Zulu war of 1879. Few people watching the film can fail to be moved by scenes depicting the massive Zulu army descending upon a relative handful of British soldiers.

Hidden away along Cranmer Road, south of Tarring village, is a small terraced house with a blue plaque adorning the front wall.

Posted to South Africa, Private Cooper had narrowly missed the overrunning of 1,300 British Army troops at the Battle of Isandhlwana just days before. Sent away to fetch supplies, he found himself at Rorke's Drift becoming one of just over 150 British and colonial troops to hold off an army of 4,000 Zulus on 22–23 January 1879. Perhaps surprisingly – particularly if you have watched the film – casualties on both sides were reasonably light. It is estimated that 300–500 Zulus were killed, while the British suffered seventeen dead and ten wounded. No fewer than eleven Victoria Cross medals were awarded following the battle. Although not one of these, Private Cooper nevertheless played his part and survived the battle.

After spending some time in hospital, he was discharged from the army in 1880. His medical records show that he suffered from ill health for the remainder of his days and

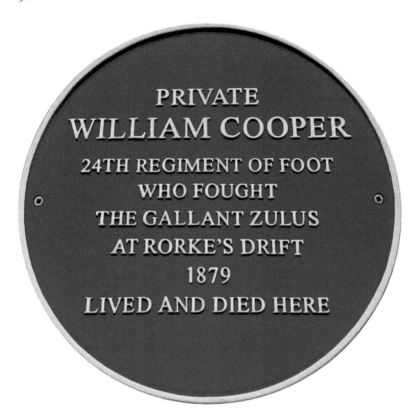

PRIVATE
WILLIAM COOPER
24TH REGIMENT OF FOOT
WHO FOUGHT
THE GALLANT ZULUS
AT RORKE'S DRIFT
1879
LIVED AND DIED HERE

The Rorke's
Drift plaque.

sadly, while suffering from depression, he committed suicide at his home aged eighty-six on 19 January 1942.

Worthing has a number of blue plaques dedicated to those worthy of note and following a campaign led by a local paper, a blue plaque was placed at Cooper's former home following a ceremony in September 2008.

The Victoria Cross, of course, is the highest military honour awarded 'for valour' during times of conflict. Traditionally cast from the bronze canons used in the Crimean War, the medal has, to date, been awarded 1,358 times since its introduction in 1856.

Montague Shadworth Seymour Moore, born at No. 13 Montague Place in 1896 is, so far, Worthing's only recipient of the honour. As a second lieutenant in the 15th Battalion of the Hampshire Regiment, Montague was only twenty years old when, in 1917 on the Western Front near Ypres, he, along with seventy men, led an attack against a forward objective. Under heavy fire, the attack was a success. However, only he and five others survived. Eventually, with the help of some sixty reinforcements, he was able to hold the position for some thirty-six hours before finally being wounded and withdrawing.

As yet, there is no blue plaque at his birthplace to commemorate someone who is Worthing's most highly honoured war hero. Montague died in Nairobi, Kenya in 1966. His medal forms part of the Lord Ashcroft Medal Collection at London's Imperial War Museum.

Better by Design

Worthing has had a bit of a reputation for being a sedate seaside retirement destination. However, in the 1960s we saw an influx of financial institutions moving south, cutting the cost of being city-bound. Beechham Pharmaceuticals, now GlaxoSmithKline, set up a 35-acre site in the industrial east of town in 1961 to meet worldwide demand. Other large companies followed suit, but there were also a couple more secretive groups operating out of sight behind the scenes.

Daewoo

The Korean car company had a design studio on the town's northern edge, known as its technical centre. Here, the Daewoo Matiz was conceived, designed, modelled as well as test driven. For four consecutive years it became the best-selling city car in their range. After hitting financial problems, it was sold to Tom Walkingshaw, better known as TWR in Formula 1 motor racing circles.

International Automotive Design

IAD specialised in car prototyping and engineering design and was based on the Ham Bridge Industrial Estate in East Worthing in the 1980s. Most of the design projects were kept under wraps to ensure a high level of security for their potential customers. Some may recall these early test vehicles on the roads with large, black, oddly shaped panels stuck on the bodywork to help disguise the design shape underneath – a kind of automotive camouflage. We do know, however, that they were approached by Mazda, who wanted to develop a British-style sports car right down to tuning the exhaust sound to imitate that so reminiscent of early MG sports cars. The end result was the Mazda MX5, which then went on to become the biggest selling two-seater sports car in the world.

Dutton Cars

This is a name that should ring some bells with car enthusiasts; it was the largest kit car manufacturer in the world. The company was founded by Tim Dutton Woolley in 1970 and ran initially from a small workshop in Worthing. It expanded to four workshops and a showroom in Broadwater before moving to Tangmere near Chichester. The most well-known and recognised cars are the P1 and later B-Type, based on parts from the Triumph Herald. In 1989, Dutton sold off all the designs to finance a new venture, before returning to the automotive industry making amphibious cars in a factory at Littlehampton, one of which was successfully driven across the English Channel.

Bibliography

Aircrew Remembrance Society http://www.aircrewremembrancesociety.co.uk/styled-15/ styled-19/styled-224/index.html

'A Little Eccentric' Ginette Leach and St Botolph's Church, Heene, with Leigh Lawson of Broadwater.

'Beach House', *Worthing Gazette* (1937).

Davis, Roger, *Tarring: A Walk Through Its History*.

Edmonds, Antony, *Oscar Wilde's Scandalous Summer* (Amberley Publishing: Stroud, 2015).

Edmonds, Anthony and Hare, Chris, *Oscar Wilde*.

Elleray, D. Robert, *The Millennium Encyclopaedia of Worthing History*.

Evans, John, *Pictures of Worthing* (1805).

Frowde. H, *Church Bells of England* (1912).

Henry, James; and Walton, Colin, 'Worthing Pub History', www.worthingpubs.com.

James, M. E. Clifton, *I was Monty's Double*.

Keech, Barrie; Kerridge, Ron; and Standing, Mike, www.oldworthingstreet.com.

Latham, Charlotte, *Midsummer Oak, Medley Of Sussex Folk Customs* (1878).

Lelliott, Graham, *A German Bomber On English Soil* (2006).

Linfield, Malcolm, *The Worthing Glasshouse Industry*.

Sussex Archaeological Society, *Tapsel of West Tarring* (1864).

'Tomatoes', *Sussex Daily News* (1906).

Warter, Revd John Wood, *The Sea-Board and the Down*.

Acknowledgements

Special thanks go to: Chris Hare; Worthing Heritage Alliance; Dennis Cochran; Roger Cloake; Paul Davison; Michael Davison; Jim Waterston; Seamus Mccabe; Worthing Library; Worthing Museum; West Sussex History Boards; Paul Holden of the *Worthing Journal*; RAF 113 Squadron, Flight Sergeant Alan Bailes 113squadron.com/id165.htm; Cyrus Elliott / Ivy Arch: Elizabeth Lane; St Botholp's Church, Heene; Friends of Worthing and Broadwater Cemetery.

Picture Credits

'Worthing Map', from T. Yeakell & Gardner, *A Topographical Survey of the County of Sussex* (1795); 'Congregational Chapel' (1870 print); 'Tin Tabernacle', Public Domain, Hassocks5489; 'Cross Street Windmill' and 'Old House Heene', George Truefitt; 'Birds of a feather', Anthony McIntosh CC; 'Arthur Conan Doyle', Worthing Spiritualist Church; 'Devonshire Dairy', in W. T. Pike, *A descriptive account of Worthing* (1894); 'Heene Chapel ruin', Leigh Lawson; 'Swandean Spitfire & Swandean Special', Michael Wilcock.

About the Authors

James Henry
Although not Worthing born and bred, James has been a resident for over forty-five years. He classes himself as a bit of a local amateur historian after developing an interest in the history, development, and later loss of Worthing's old pubs. It was inevitable that this would later expand to the town itself. James is the author of five unrelated novels.

Colin Walton
Colin has lived in Worthing all his life and has a degree in History and Archaeology. Always having had an interest in the town's past, he is a Worthing Heritage Tour Guide and a collector of local history books. He has a specific interest in Worthing pubs and is co-author of a website devoted to their history.